Basic People Painting
TECHNIQUES IN
WATERCOLOR

D1261842

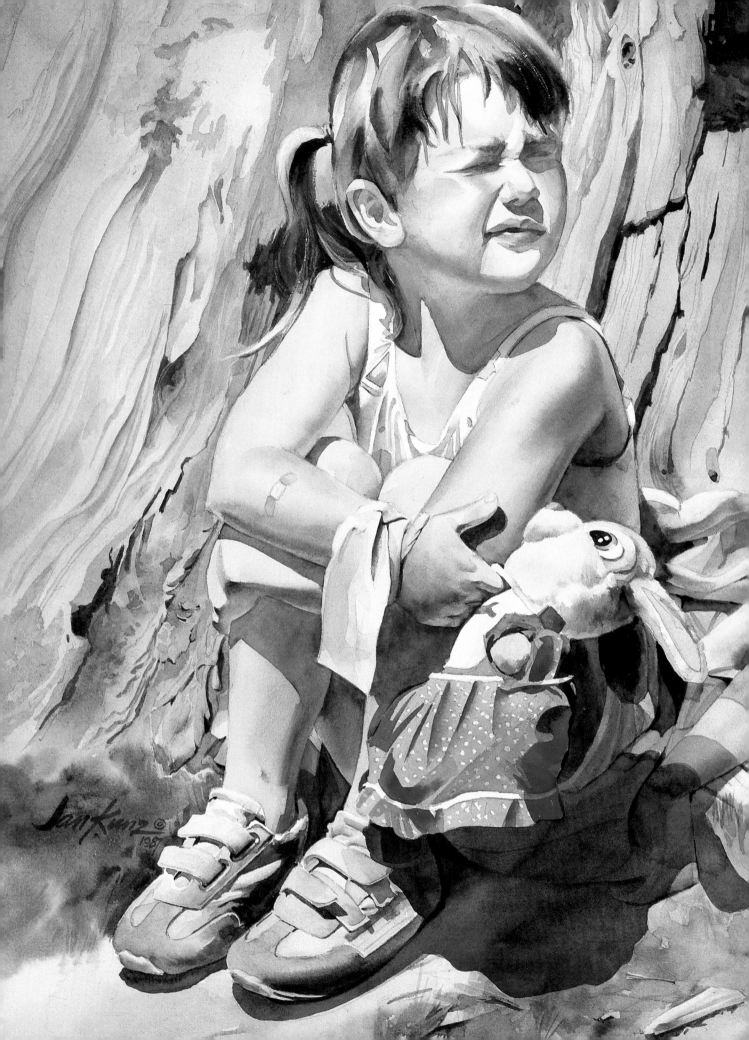

Basic People Painting

TECHNIQUES IN
WATERCOLOR

Edited by

RACHEL RUBIN WOLF

NORTH LIGHT BOOKS
CINCINNATI, OHIO

Other fine North Light Books are available from your local bookstore, art supply store or direct from the publisher.

02 01 00 99 98 7 6 5 4 3

Library of Congress Cataloging-in-Publication Data
 Basic people painting techniques in watercolor / Rachel Rubin Wolf, editor.
 p. cm.
 Includes index.
 ISBN 0-89134-731-3 (alk. paper)
 1. Portrait painting—Technique. 2. Human figure in art. 3. Watercolor painting—Technique. I. Wolf, Rachel Rubin
ND2200.B37 1996
751.42′242—dc20

95-48892
CIP

Edited by Rachel Rubin Wolf
Content edited by Beth Struck
Designed by Angela Lennert Wilcox
Cover illustration by J. Everett Draper

The material in this compilation appeared in the following previously published North Light Books and *The Artist's Magazine* and appears here by permission of the authors. (The initial page numbers given refer to pages in the original work; page numbers in parentheses refer to pages in this book.)

Cain, Barbara George. "Giving Shape to Watercolors," *The Artist's Magazine*, © July 1991. Pages 46-49 (pages 36-39).
Clark, Roberta Carter. *Painting Vibrant Children's Portraits* © 1993. Pages 62-67, 36-37, 30-35, 88-91, 28 (pages 88-93, 94-95, 96-101, 112-115, 124)
Draper, J. Everett. *Putting People in Your Paintings* © 1985. Pages 96-107, 114-119 (pages 58-69, 70-75).
Johnson, Cathy. *Creating Textures in Watercolor* © 1992. Pages 108-111, 102-105 (pages 116-119, 120-123).
Katchen, Carole. *Dramatize Your Paintings With Tonal Value* © 1993. Pages 124-127 (pages 40-43) by Stephen Scott Young.
Kunz, Jan. *Jan Kunz Watercolor Techniques* © 1994. Pages 58-62, 43-47 (pages 102-106, 107-111). *Painting Watercolor Florals That Glow* © 1993. Pages 4-9, 12-13 (pages 10-15, 16-17). *Painting Watercolor Portraits That Glow* © 1989. Pages 44, 82, 80-81, 90-95, 104-107, 89 (pages 2, 6, 76-77, 78-83, 84-87, 125).
van Hasselt, Tony and Judi Wagner. *Watercolor Fix-It Book* © 1992. Pages 114-123 (pages 48-57).
Vrscak, Bill. "Body Building in Watercolor," *The Artist's Magazine*, © March 1989. Pages 82-87 (pages 30-35).
Westerman, Arne. *Paint Watercolors Filled With Life and Energy* © 1994. Pages 91, 87, 36 (text only), 18-19 (art only), 37-45, 54-55, 112-113, 106-107 (pages 5, 8, 18, 19 (art), 19-27, 28-29, 44-45, 46-47).

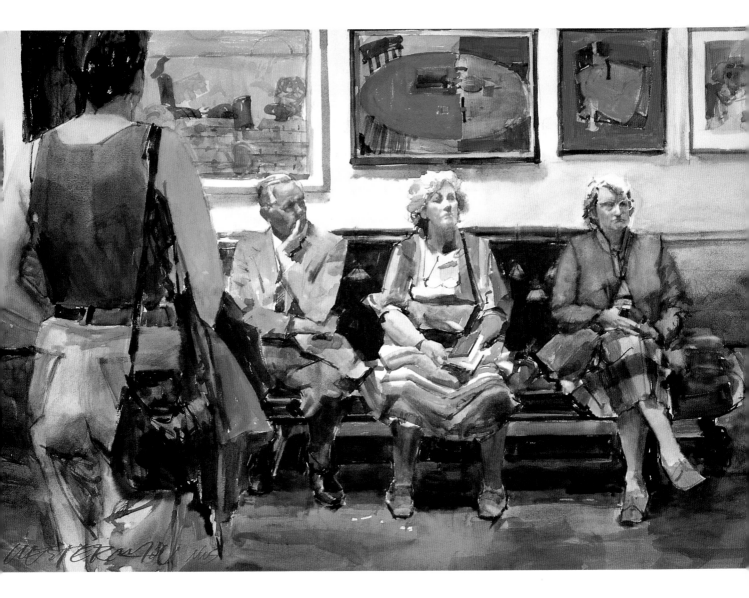

ACKNOWLEDGMENTS

The people who deserve special thanks, and without whom this book would not have been possible, are the artists whose work appears in this book. They are:

Barbara George Cain

Roberta Carter Clark

J. Everett Draper

Cathy Johnson

Carole Katchen

Jan Kunz

Tony van Hasselt

Bill Vrscak

Judi Wagner

Arne Westerman

Stephen Scott Young

TABLE
of
CONTENTS

INTRODUCTION

No other painting medium comes close to the purity of color and radiance of transparent watercolor. The key to success with watercolor is developing an understanding of the medium's unique character. This book will show you how to take advantage of watercolor's special properties in rendering realistic paintings of men, women and children of all ages.

We have assembled this book from some of the best teaching on watercolor and figure painting—everything you need to get off to a smooth start. In the first chapters you will find useful information about materials and techniques, color and design. The latter part of the book teaches basic principles of figure painting and, through demonstrations, covers the figure-painting process from head to toe . . . and everything in between.

The only additional ingredients you will need are practice and the knowledge that interest and effort overcome any lack of that elusive quality called "talent."

Tools and Materials

This section is aimed at the painter who is new to watercolor and needs to get outfitted. For those of you who have been painting for a while, you may not need new supplies; however, look at your palette and check that all the pigments, as well as the mixing areas, are clean.

Brushes

There was a time when the only good brushes were made of sable hair and were very expensive. Happily, that has changed, and there are many good synthetic brands on the market.

Select a brush that holds a good quantity of water and springs back into shape after each stroke. Most good art supply dealers will supply you with a cup of water with which to test a brush before purchase.

The size brush you choose should fit the job for which it is intended. Just as you wouldn't paint a house with a trim brush, you shouldn't try to run a wash with a tiny brush or paint petals with a mop!

You don't need to have all of the brushes pictured. If you have a no. 14, 8 and 4 round and a 1-inch flat brush, you'll get along very well. The more you paint, the more brushes you'll collect. Remember that old saying about a craftsman being only as good as his tools? They were talking about watercolor brushes!

Modified Oil Brushes

There will be times when you want to scrub out an offensive spot, lift a highlight or soften an edge. That is where modified oil brushes come in handy. Perhaps you can persuade an oil-painter

friend to donate a couple of old bristle brushes to the cause.

You can modify two oil brushes for special use (as shown at right). The first is a flat no. 6 bristle brush used to lift highlights and make corrections. The tip of this brush is cut shorter to enhance its stiffness. The second brush is a round no. 2 bristle brush. The tip of this brush is cut at an angle to form a point, creating a great tool with which to lift small highlights.

Some artists modify brushes by wedging the bristles between heavy paper and cutting the tips with a utility knife. It works just as well, however, to wrap the bristles tightly with masking tape, and then cut them with scissors or an X-Acto knife right through the masking tape. The tape will come off easily after the surgery.

You can create a useful tool for drawing on damp paper by sharpening the handle of one of these brushes in a pencil sharpener.

One other oil brush (not pictured here) that some artists find useful is a flat no. 2 Grumbacher Erminette. It is small, only about ⅛-inch wide, and is used to soften edges. This little brush is not too stiff and is very maneuverable.

Palette

The selection of a palette is a matter of personal choice, but be sure to choose one with deep wells to hold the paint and large areas for mixing. A baked enamel palette does not stain readily and fits easily under the faucet for cleaning. Try a large 16″ × 11¼″ butcher tray for mixing big washes. A number of convenient-to-use white plastic palettes are available at any art supply store.

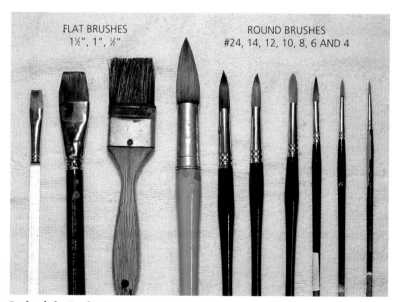

FLAT BRUSHES
1½", 1", ½"

ROUND BRUSHES
#24, 14, 12, 10, 8, 6 AND 4

Tools of the Trade *These brush sizes are the ones you'll use most often. A good brush can be a good friend for a long time.*

Pencils

To make graphite transfer paper (see page 12), you will need a 4B or 6B graphite stick or one of those pencils that is entirely graphite, such as a Pentalic Woodless Pencil. For sketching in the field, try an HB and a 4B. For preparing a drawing in the studio, use an ordinary no. 2. Too hard a pencil will scar the paper, and a soft one will make a thick line and dirty both the paper and your hands.

Everyday Tools

You'll find a variety of everyday things that can contribute to your paintings. An old towel or rag is useful for spills. You'll need a sponge and facial tissues to dry brushes and blot areas of your paintings. Artificial sponges are available at hardware stores, but be sure you get one made of *cellulose*. Other artificial sponges are not absorbent enough. A small, elephant-ear-shaped natural sponge is useful for lifting out light areas in a wet painting. Some artists prefer terry cloth bar towels for lifting colors. These towels are about 14- to 16-inches square; you can buy them from a restaurant supply house or by the pound from a laundry after they are too old for commercial use. These towels are rugged and clean up easily in the washing machine.

Facial Tissues

It is difficult to paint without facial tissues. You need them to wipe out the palette, pick up a spill or remove a misplaced color.

Knife

An X-Acto knife or razor blade is a useful tool for shaping acetate frisket or picking out a highlight.

Liquid Frisket

Liquid frisket is used to mask areas you want to protect when applying washes of color. Use it sparingly, though, because it creates hard edges. There are times, however, when painting around objects is simply impractical, and nothing else will do as well.

Liquid frisket is sold at most art stores. Winsor & Newton calls theirs Art Masking Fluid, and Grumbacher's brand is Misket. Liquid frisket can ruin your brush if you aren't careful, so follow the directions on the bottle.

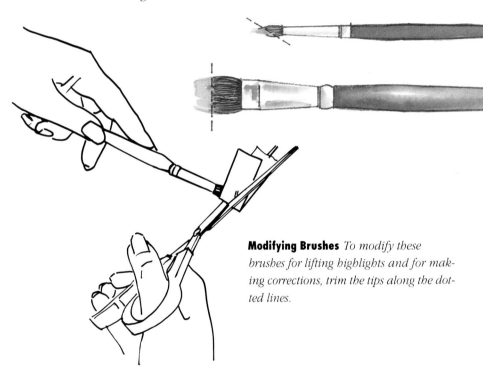

Modifying Brushes *To modify these brushes for lifting highlights and for making corrections, trim the tips along the dotted lines.*

Homemade Clean-Up Tool *Wrap the tip of an oil brush with masking tape and trim it with scissors or knife to make a useful clean-up tool.*

Watercolor Paper

Have your paper, drawing board and filled staple gun ready before you begin.

If your paper is too large to fit into the sink, make into a soft roll and gently submerge it. Be careful not to fold or scar the paper. Hold it under water until every part is thoroughly wet.

Remove the paper and lay it on your drawing board. Immediately staple opposite sides of the paper. Continue around the entire board, placing staples two to four inches apart.

Many watercolor instructors urge beginning painters to work on good quality watercolor paper. What is good watercolor paper? If you don't know how to judge good paper, start with a brand name that artists recognize as top quality. The best paper is 100 percent rag, hand- or mold-made. Some of the top brands include Arches, Holbein, Fabriano, Winsor & Newton and Strathmore watercolor board.

Most papers come in three surfaces: hot press (smooth), cold press (medium) and rough. In addition, watercolor paper comes in various weights. The most popular are 140-lb. and 300-lb. (The weight refers to the weight of 500 sheets.) A standard sheet is $22'' \times 30''$. You can also purchase larger (elephant-size) sheets, or buy it by the roll.

Stretching Paper

Stretching paper prevents it from buckling once water is applied. If you plan to use 140-lb. paper, stretch it first. There's enough to think about while you are painting without worrying about wrinkled paper. Stretching isn't required for 300-lb. paper.

Stretching paper is easy. Have everything ready beforehand because you don't want the paper to begin to dry while you are working with it. You will need a drawing board slightly larger than the paper. Basswood, foamcore or "gator" board all work well. You will also need a filled staple gun. You can use a regular desk stapler, but if your board is extremely hard, you may need the heavier industrial type.

Fill a large container—even a sink or bathtub—with cool water. Place the paper in the water. If it doesn't fit, make it into a soft roll. After two to five minutes (and when you are sure the entire paper is thoroughly wet), remove the paper and place it down flat on your drawing board. Immediately begin to staple all around the edges, placing a staple about every two to four inches. Paper exerts a great deal of pull as it dries, so be sure the staples are well in place. Roll a clean terry cloth towel over the surface of the paper to pick up excess water and speed drying. Lay the drawing board on a horizontal surface to dry. You don't want the water to run to one side and cause a buckle.

Transfer Paper

People have many complicated shapes, so many artists like to do their planning on tracing paper. Once they're satisfied with their drawings, they transfer them onto watercolor paper. You can use either a commercial transfer paper or homemade graphite paper. When you use the paper you make yourself, it's almost like drawing directly onto your watercolor paper. Commercial papers sometimes leave a line you cannot erase, as well as a white margin on either side that repels the paint.

To make graphite transfer paper, you

need a piece of good quality tracing paper. Cut the tracing paper to convenient size making it large enough to use again and again with various size drawings.

Rub one side of the paper with a soft graphite stick or woodless pencil until it is pretty well covered. A crisscross motion works very well. Once the paper is covered, dampen a piece of facial tissue with lighter fluid or rubber cement thinner. Using a circular motion, rub over the blackened surface. The graphite will smear at first, but keep rubbing until the surface takes on a uniform value. When the transfer paper is finished, bind the edges with tape to keep the paper from tearing after repeated use.

Before you use your new transfer paper, shake or dust all the excess graphite from its surface to prevent its soiling your watercolor paper. Use it just as you would any other transfer paper. Put it beneath your drawing, graphite side down, and trace your drawing onto the watercolor paper.

Frosted Acetate

Frosted, or matte, acetate (depending on the brand name) sheets are translucent, and the surface readily accepts pen or pencil. The acetate sheets should be thick enough to withstand handling (0.005 or 0.007 is best). Some good brands I use are Grafix Acetate or Pro/Art. You will find many uses for frosted acetate. Since it's nearly transparent, you can draw on several pieces, and then superimpose them on one another to create a composition. You can also make an acetate frisket for use when lifting problem color from small areas. Just place the acetate over the painting and use a pencil to outline the area to be lifted. Remove the acetate and carefully cut out the outlined shape with an X-Acto knife. Next, replace the acetate frisket over the painting and lift the color with a moistened stiff brush (like the modified oil brush). Corrections of this kind nearly defy detection, but they should be used only when the painting is near completion. Stiff brushing can distress the paper to the point that it will not accept more pigment well.

Paintable Acetate

Paintable or wet-media acetate is specially treated to accept watercolor. It can be used to "try-out" an addition or correction to your painting. Simply lay it over your painting, make your alteration, and see if you like the visual effect. If not, just try again without disturbing your painting.

Place frosted acetate over the painting and outline the area you wish to lift.

Move the acetate to a piece of cardboard or thick paper, and cut out the shape you have outlined.

Replace the acetate into position over the painting and remove the offending area with a damp, stiff brush.

Paint

In this book you will be working with transparent watercolors. The pigments that come in tubes are easiest to work with. You can squeeze out a fresh amount when you begin a painting, and the soft consistency makes them easy to use.

Many people consider all water-based paint to be *watercolor*, including acrylic, tempera or gouache. Be careful to get transparent watercolor. The label will read something like "water colors artists' quality," "artists' water colour" or "professional artists' watercolor," depending on the brand.

There are many good brands of watercolor pigments. Well-known names include Winsor & Newton, Grumbacher, Holbein and Liquitex. The color may vary slightly between different brands, but the quality remains consistently high.

How artists arrange pigments on their palettes varies. Many artists place warm colors on one side and cool on the other side. If you are happy with the way your palette is arranged, stay with it. The arrangement isn't nearly as important as knowing where a pigment is located. You don't want to stop and look around the palette for a special color while the wash is drying!

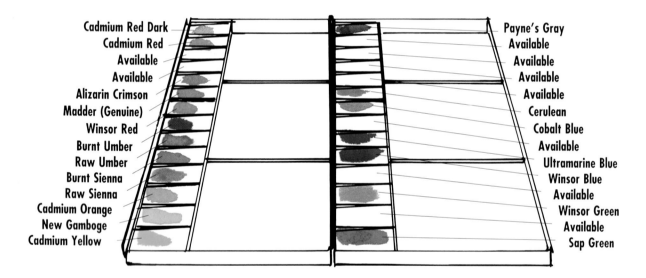

Cadmium Red Dark
Cadmium Red
Available
Available
Alizarin Crimson
Madder (Genuine)
Winsor Red
Burnt Umber
Raw Umber
Burnt Sienna
Raw Sienna
Cadmium Orange
New Gamboge
Cadmium Yellow

Payne's Gray
Available
Available
Available
Available
Cerulean
Cobalt Blue
Available
Ultramarine Blue
Winsor Blue
Available
Winsor Green
Available
Sap Green

A Colorful Palette *These are the colors one artist keeps on her palette. The available spaces are used when she wants to add a special color for a particular painting, such as Rose Dore, Thalo Red, Winsor Violet, Cobalt Violet, Hooker's Green Dark, Prussian Blue, Antwerp Blue or Manganese Blue. She does not own a tube of black pigment.*

Painting Tips

It may seem like a trivial thing, but a well-organized work space can help you work more efficiently. When painting, your entire concentration should be on the painting itself. By the time you put brush to paper, everything else should be in order. A clean paint rag should be positioned next to your palette for immediate use. The water bucket should be large and full of clean water. All the brushes you might need should be placed for easy access in a jar or carrousel, and facial tissues should be within reach.

Clean Your Palette and Paint

Palettes get dirty, so wipe yours out frequently. When cleaning your palette, don't overlook the pigment. Color is transferred from pigment to pigment during the painting process, and colors can lose their brilliance. When this happens, take your palette to the sink and run a gentle stream of cool water directly onto the pigments. Then, using one of your small brushes, gently remove any color that doesn't belong. Next, give the palette a quick shake to remove excess water and wipe it dry. Be careful if the pigment is fresh. Even at that, you'll lose very little pigment, and what is left will be fresh and brilliant.

Small Cautions That Can Help

Keep the water container filled to the top so you won't miss the water altogether. It's easier than you think to bring a dry or dirty brush to the paper! Use a clean paint rag and replace it as necessary.

Most Important Tip

Don't listen to any of this advice if it doesn't sound right for you. That goes for any other advice you may have heard. Watercolor painting is a very personal experience. You are in charge. Have faith in your own ability to know what works for you.

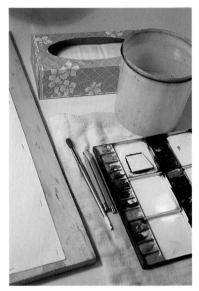

Work Space Setup *A well-organized work space can make painting easier. Your paint rag, water and facial tissues should always be within easy reach.*

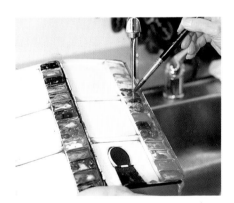

A Clean Palette *Use a gentle stream of water to clean your palette and the pigments during the painting process.*

Color and Watercolor

Color is a highly personal element, and discovering how to use it effectively is a hands-on process. Learn all you can about color; make use of the many fine books available on color and color theory.

Although some of the following information may seem rather basic, this quick review may remind you of some things long forgotten. Anyway, like chicken soup, "It can't hurt!" If you are new to painting or are unsure about color, this is information you need.

What Is Color?

We sense color when our eyes are struck by light waves of varying length. Our eyes pick up these waves and translate them as light. If there is no light, there is no sight, as you know if you have ever experienced total darkness.

Even though we call it "white light," the light that comes from the sun contains all the colors we see around us. Every colored object we see contains pigments that have the ability to absorb certain rays of color and reflect others. For example, a banana is yellow because the pigment in its skin reflects only the yellow light we see and absorbs all the other colors. Through the years, some materials have been found to be especially rich in pigment. These are the materials that are purified and made into the paints we use.

Hue

Hue is the term used to name a color. Red, green, yellow and blue are hues. It has nothing to do with whether the color is intense or pale, dark or light.

Primary Colors

The *primary colors* are red, yellow and blue. These colors cannot be made with a combination of any other pigments.

Secondary Colors

Secondary colors are those colors we can make by mixing the primary hues. If you study the color wheel, you'll see that each secondary is a combination of the primaries on both sides of it. Red and blue make purple. Red and yellow make orange. Blue and yellow make green. All the other colors are some mixture of the three primaries and three secondary colors.

Complementary Colors

A color wheel is created when we place the primary and secondary colors equidistant from one another and then fill in the spaces by mixing adjacent colors. The colors located opposite one another are called *complementary colors.* Red and green, yellow and purple are examples of complementary colors. When complementary colors are mixed, the result is a neutral gray. Complementary colors, in dark values, are almost always muddy.

Warm and Cool Colors

When we speak of warm and cool colors, we are talking about color *temperature*, not about value or color intensity.

Many of the pigments we use in watercolor have warm and cool versions of the same color. Alizarin Crimson is a cooler red than Cadmium Red, for example. The colors on the left of the chart, shown at the top of page 17 are somewhat warmer than those on the right.

Value

Value refers to the lightness or darkness of a color. Different pigments have dif-

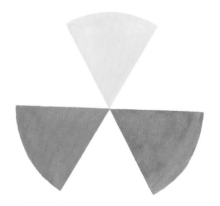

Primary colors

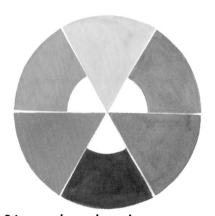

Primary and secondary colors

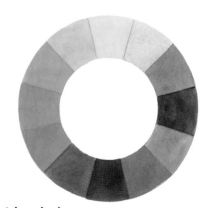

Color wheel

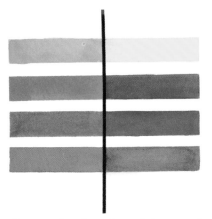

Warm and cool versions of the same hue

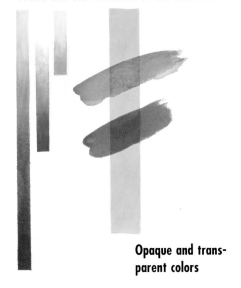

Opaque and transparent colors

Pigments have different value ranges

ferent value ranges. *Value range* refers to the number of intermediate values you can get by using a color directly from the tube (darkest value) and then adding water until it becomes a faint tint. In the examples at right, yellow, at its darkest, has only a short value range. Alizarin Crimson, on the other hand, has a very long value range. Cobalt Blue's value range is somewhere between the two.

Watercolor Pigments

Most professional watercolor pigments are permanent and chemically stable. Certainly, they are as enduring as oil pigments. Watercolors do have unique qualities that we need to understand.

Opaque and Transparent Pigments

You don't have to work with watercolor very long to become aware that there are two kinds of watercolor pigments. Some pigments display a fair degree of opacity while others are extremely transparent.

Think of *opaque* (or *precipitating*) colors as being little microscopic granules of pigment. When we paint with opaque colors, these little chunks of pigment remain deposited on the surface of the watercolor paper. When light is returned from an opaque color, it reflects only from the pigment granules.

Transparent (or *staining*) colors are more luminous than opaque ones. The reason is that light rays penetrate the thin film of transparent pigment and reflect the white paper beneath.

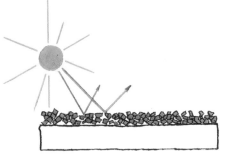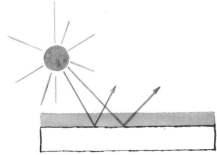

Light bounces off color granules of opaque pigments, but light reflects the white paper beneath transparent pigments.

Composing Your Painting

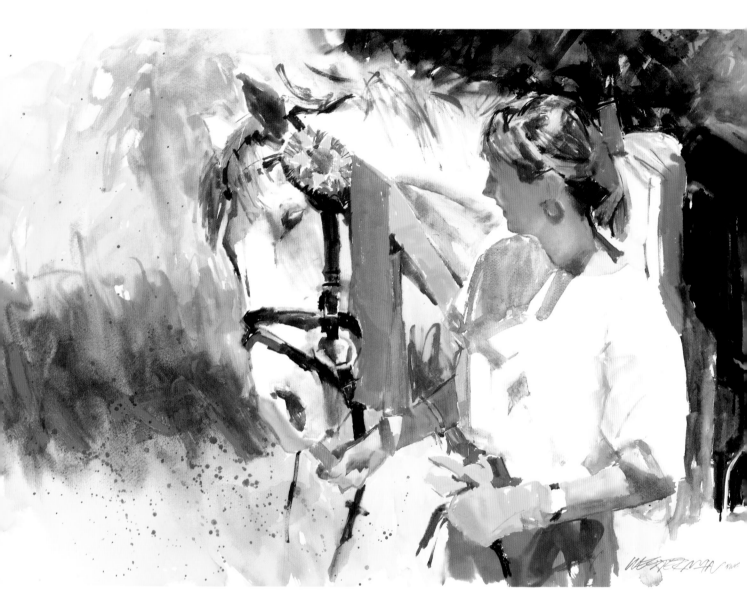

Most paintings that fall short share a common problem: They may include technical skills and contain some well-done portions, but as paintings, they just don't hold together.

The missing ingredient is *design*. The work frequently is the result of an inspired artist rushing headlong into covering the paper with a beautiful thing, and the *thing* has come out beautiful but the *painting* hasn't. How often have you looked at a painting you thought finished and wondered why it never got there? This is where we find out.

When designing a car, fussing with the exterior may be fun, but without structure it won't go anywhere. Likewise, you need a framework for building a painting—that framework is the design. Before you put brush to paper, there are decisions to make on the structure and composition of your painting.

The Basic Rectangle *A unified rectangle that consists of a vertical block composed of horse and rider takes up about two-thirds of this horizontal rectangle. The artist made the connection to the left side of the painting with a purple shape, which starts from the shadow on the rider, past the horse and to the edge.*

A Carrot for the Winner, 25" × 36"
Arne Westerman

Vertical or Horizontal?

The first decision starts with the basic rectangle. That's *all* you have to work with. You'll need to decide which rectangle—horizontal or vertical—offers the most exciting potential for your subject matter, and only then can you begin to create a painting.

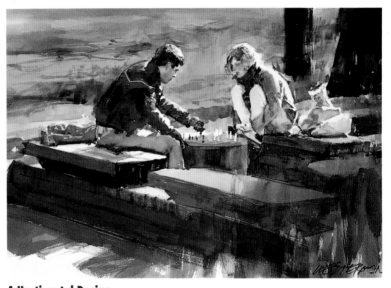

A Hortizontal Design
Winter Chess Match, 17" × 26"
Arne Westerman

Vertical or Horizontal? *Someone's daughter, niece, friend, daughter of friend, etc., and if it's going to be a painting, you have two choices: Will it be most interesting as a horizontal? Or a vertical?*

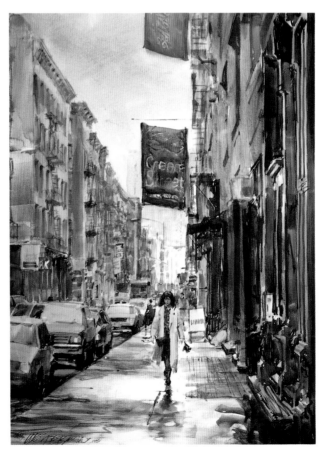

A Vertical Design
*Greene Street,
Rainy Day,
36" × 25"*
Arne Westerman

The Basics of Composition

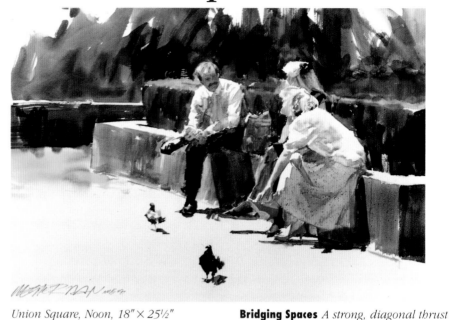

Unify the Rectangle

Unify the rectangle with lines or shapes that connect to all four sides through upward, diagonal and sideward forces. Even when these lines are interrupted, the eye will bridge the empty spaces and mentally make connections to the sides, bottom and top of the painting. Bridging the gaps in a form or within a painting is called *closure*.

Basic Structures

Some basic patterns offer the artist ready-made designs. Three of these are the *pyramid*, *axial* and *divisions of space* (see below).

Union Square, Noon, 18" × 25½"
Arne Westerman

Bridging Spaces *A strong, diagonal thrust connects the sides of the painting. The artist has also connected to the top of the painting, and the pigeon is the connection to the bottom. See how your eye bridges the gap. Cover the pigeon with your hand, and you'll see that the painting doesn't work nearly as well.*

Horizontal and Vertical Connections *The eye will bridge the space between a broken horizontal, diagonal or vertical line, and mentally fill in the connection. Thus, vertical or horizontal thrusts may have breaks and still seem connected to make a cohesive painting.*

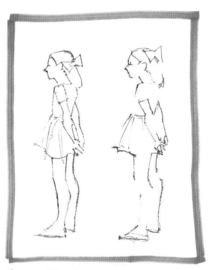

Closure *What lines or things can you leave out to add sparkle to your work? The viewer is delighted to make the connection.*

The Vignette *Even a vignette must appear to connect the sides, the top and the bottom of the rectangle.*

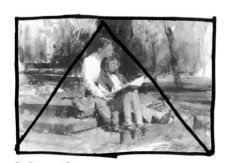

1. Pyramid Structure

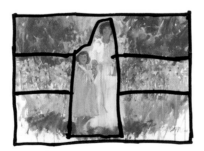

2. Axial

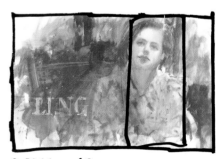

3. Divisions of Space

Rhythm

Repetitive shapes create a feeling of movement or flow. The shapes needn't be perfectly similar to generate this effect.

Balance Your Elements

Arrange positive shapes to balance negative shapes, large shapes against small ones. Your paintings must have balance and variety to keep them from appearing static and uninteresting.

Combine several elements, and you create a larger shape to balance others. You can use light and dark values, lines, shape, texture and color to create balance.

Focal Point or Dominance

Your composition must have a single center of interest, a clear message. The viewer's eye will be drawn first to your area of most interest through contrast, color, size or the most interesting shape. The painting should convey immediately what's the most important area and areas of secondary interest. In a portrait, the face will invariably be the starting point.

Entrance and Exit

You decide on the areas of progressively less importance and encourage the viewer to travel the path you design. A door, window or patch of sky can offer a subtle exit.

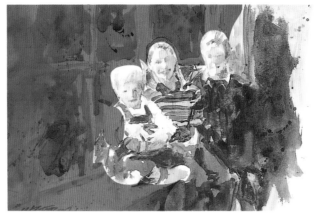

Lane Children Study, 26″ × 37″
Arne Westerman

Balance *This portrait of three children displays a nice balance between positive shapes and negative space (represented by the red area). Notice how the figure forms are connected to each other and to the background.*

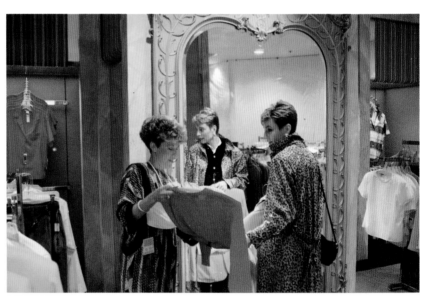

Dominance and Simplification *This is a typical retail scene, which connects with the experiences of most of us. If you include everything the photo tells us, the painting will look like the number-three special from a Chinese menu. Start by choosing a single focal point and simplifying.*

Combined Shapes *This is the abstract shape of the painting if you make the shopper our center of interest. Her mirror reflection and the salesperson have been subverted by combining shapes and adding tones.*

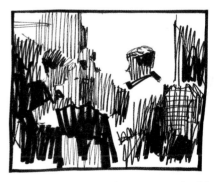

A *Value*-able Lesson *Eliminate much of the mirror and frame, and tie the salesperson into the background with lost shapes. The reflection of the customer drops in value and is tied closer to the mirror.*

Shapes and Tonal Value

Subject Matter and Shapes

Subject matter is the beginning, not the completion, of a piece of art. Look beyond the obvious shapes of heads, bodies, buildings, etc. Try to find interlocking patterns and variety. Change many of the obvious shapes and create new ones. Look for patterns in background or foreground that can tie elements together and add excitement or interest to your composition.

Simplify! Simplify! Simplify! Cut out the junk that can complicate your composition. Eliminate anything that doesn't express your feelings simply and clearly. (Maybe your painting doesn't need all twenty-four people in the background plus the fire truck and the telephone pole.) Subordinate, combine or delete. Keep background shapes in the background.

Value: Light and Dark

Establishing good, strong values in your composition is more important than technique or color. It makes your painting read and identifies your meaning. Create stronger contrasts to attract and direct attention to important areas and to improve composition. Connect contrasting areas with middle tones.

You can test how good the composition is. Reduce it to black, gray and white; squint to let your eye see it that way. Color can be misleading and may often camouflage a mediocre piece of work.

Abstracting the Shape *A beautiful ballerina, but . . .*

. . . it's only a vertical line in a rectangle.

It needs additional shapes to create a complete painting. How about including a larger figure on the left and perhaps a smaller one on the right? Look for the connections with other dancers, with the wall and floor.

Basic People Painting Techniques in Watercolor

Building Shapes *A seated model, a blank white wall and a dark floor are all the art-ist had to start with. What elements must be included in the way of background and new shapes to create a painting?*

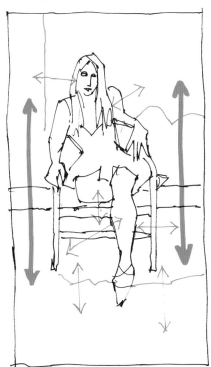

Go beyond the edges of the figure and build new shapes. Some background color invades the hair and arm on the left. Come in strongly on the upper arm on the right. Much of the chair and the dark sides of the legs are lost in shadow shape.

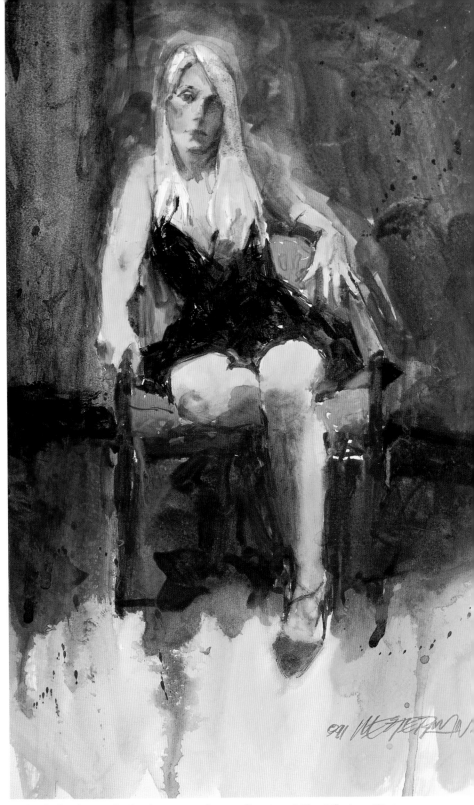

Christina, 20" × 11", Arne Westerman

Melancholy Blue *In the final painting, the artist has added something blue to break up the background. Could it be a curtain? He has made the background heavy to build a feeling of melancholy. He has also devised a blackish floor moulding set on a slight diagonal to create additional tension.*

Lines

Lines serve to outline shapes, express movement and generate strong interest. Horizontal lines impart feelings of tranquility. Diagonals convey action, movement, conflict. The eye follows the line wherever it leads (both *into* and *out of* the painting) and automatically goes to the point where lines come together and cross. Avoid lines that go to the edges and draw your viewer right out of the painting.

Use lines with some discretion. Don't slavishly color inside lines the way we learned as children. The results will remind your viewer of a coloring book, and you'll wind up with lots of little, boring shapes in your painting. It's time to get out of the habit. Draw lines you paint past, lines you erase to eliminate divisions between shapes, and lines you add while you paint or after your painting dries to describe abstract shapes. Subtract lines to lose edges.

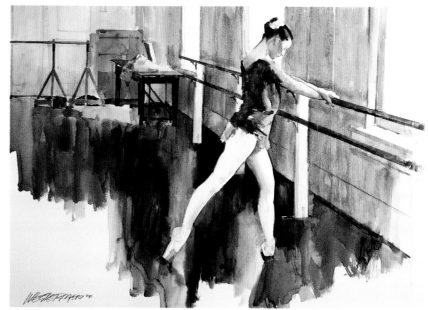

Repetitive Lines Create Rhythm *In this ballet scene, repeating diagonal lines of the ballet barres, leg and floor create action. In* Hats and Scarves, *rhythm is created by repetitive circles.*

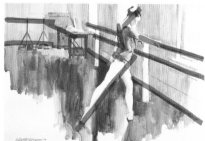

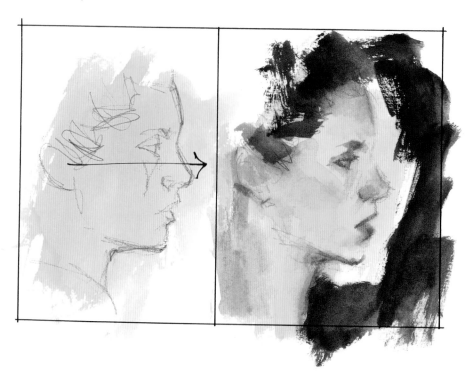

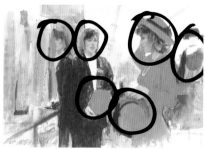

Cutout Figures *Avoid making your figures look like they have been cut from magazines and pasted on your painting. You can make them belong by keeping them loosely drawn and tying them into the background.*

Basic People Painting Techniques in Watercolor

Lost and Found Edges

S harp edges attract attention. Lose edges to create movement, to lock the figure or thing into its environment. What is left out is often more important than what is left in. Create new shapes by tying together areas of similar color or value and by subtracting lines between shapes. Lose edges and blur details because the area outside your central field of view is naturally blurred. If you need to restate a line or portion, you can always do it later.

Avoid *tangents*. These are lines that run parallel to the places they touch and may serve to confuse shapes. For example the edge of a building that touches and follows the edge of an arm. Better to have it intersect at the shoulder, or to pull it further away from the figure. Look out for things that appear to grow out of your figures, such as telephone poles.

Lost and Found Edges *A painting of Hilary, showing how the artist lost light-struck edges of the figure against the lights of the background. Yet, in spite of the subtraction, the parts "read" clearly.*

Hilary, 14" × 10", Arne Westerman

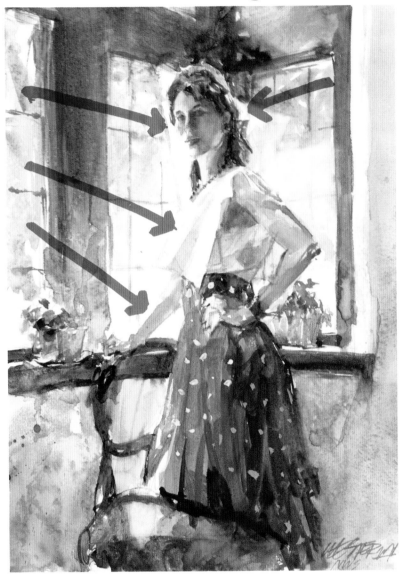

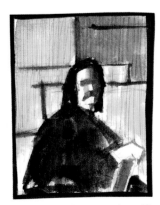

Intersecting lines *in the self-portrait by Poussin show background shapes and come at the figure at right angles.*

Tangents *confuse the shape. Avoid lines that run to or connect with parallel edges.*

Avoid things growing out of your figures. *Move the telephone pole away from your figure or forget it.*

Don't let things grow out of someone's face, *as in this sketch from the self-portrait of Gustave Caillebotte.*

Other Important Considerations

Texture

Texture gives the viewer the vicarious experience of feeling a variety of effects. Decorative texture in the form of patterns in the wallpaper, clothes or furniture may add movement, depth and excitement to a painting. See the paintings of Vuillard for his wonderful use of pattern. Note that where his figures and background are similarly patterned, only the figure has volume; the background is flat. Minimize natural textures like stone or brick. They can become too prominent and monotonous.

Drips and spatter add another textural dimension. Wet paint on hot-press paper dries with a special effect. Scrub with watercolor or oil brushes to get a look similar to oils. Don't confine texture to a single area. Use it throughout your painting.

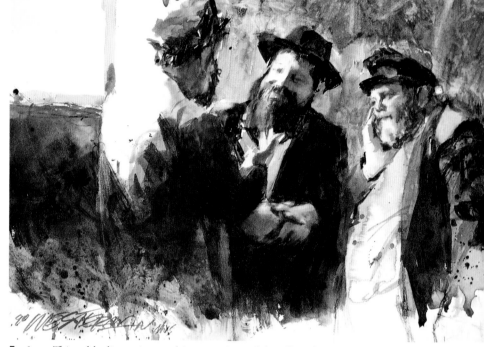

Texture *This adds dimension and interest. One of the effects in this painting is made by a combination of bearing down with a brush and spraying, which loosens and separates the paint. While the painting was wet, the artist set it somewhat vertically to get some nice drips. He added spatter by simply throwing a brushload of paint at the work.*

The Old Schul,
9½" × 13"
Arne Westerman

Gradation

Any gradual transition in color, line, value, size, etc., is called *gradation*. It creates the illusion of curvature and volume. Objects appear to recede. Gradation can also suggest movement, acting almost like an arrow drawing the viewer into an area of contrast.

Illusion of Depth *The artist has used an advancing color and an overlapping shape to establish the foreground. Another supporting and overlapping figure creates deep space for the center of interest. Try a large, partial figure in the foreground, or a large tree (or whatever) and watch the effect.*

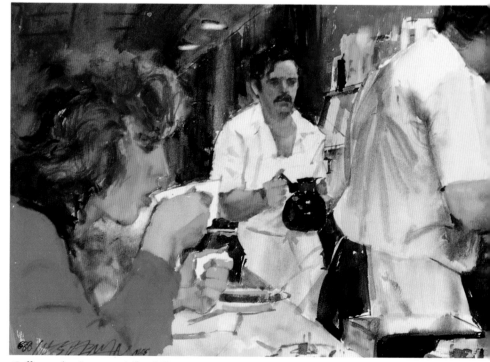

Coffee at the Counter, 14" × 20", Arne Westerman

Basic People Painting Techniques in Watercolor

The Illusion of Depth

Add depth to your painting through perspective, gradation, comparative size, advancing and receding color, and overlapping shapes. Creating a foreground, middle ground and background adds the three-dimensional illusion.

Flat Shapes

The Impressionists, following the influence of Japanese prints, simplified shapes by flattening them. The result is more exciting than defining folds and contours, which may look too photographic.

Isolation of Elements

An isolated figure or element will draw attention to itself. This device may be useful in presenting your principal point of interest. An element placed near a picture border tends to have greater attraction than one placed in the center. Similarly, an isolated element may have more weight and interest than one that's more closely related to others.

Warm or Cool Colors

Warm and cool colors play against each other. Cool colors recede and warm colors advance. A warm color against a cool background will draw attention to itself.

Local or Arbitrary Colors

Do you want to paint what you see or what you feel? *Local color* means the actual color of the object. *Arbitrary color* is any color you select for dramatic effect.

High Key or Low Key

Are you going to design your scene to be a light, airy painting or a dark moody, dramatic one? You choose the effect that your feelings and subject matter suggest. Look over some paintings you like, to see where these elements were used in making them successful. Look over your problem paintings. Are there shortcomings in the area of composition?

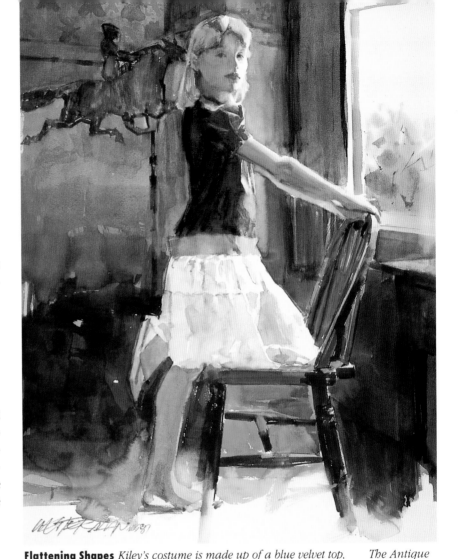

Flattening Shapes *Kiley's costume is made up of a blue velvet top, pink sash and ruffled white satin skirt. Since the suggestive is more interesting than the explicit, the artist painted the colors flat with little or no feeling of volume. He left some light-struck areas and added various tints to represent white satin.*

The Antique Weathervane, 24½" × 16½" Arne Westerman

The Isolated Figure *A lone person draws disproportionate attention. Although the bulk of space is devoted to a mass of figures, the eye bridges the gap and goes automatically to the isolated one.*

Arbitrary Color *Will the design be affected by a choice of arbitrary colors? Will you paint things as they appear in nature, or will you change colors to correspond to your feelings and subject?*

Three Ways to Light a Figure

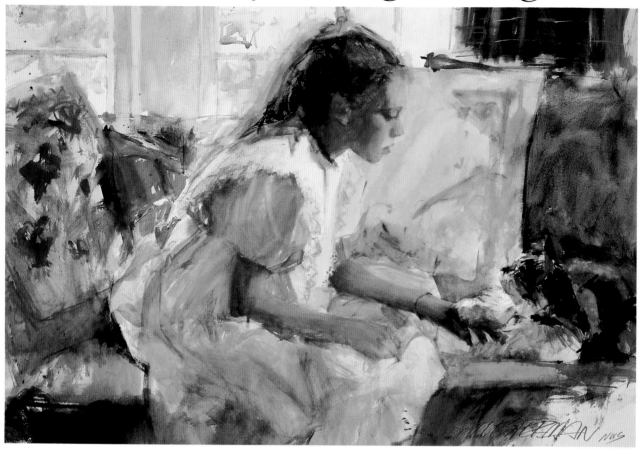

Window Light *This scene is lit by two windows, as you can see by the small diagram at right. The artist intensified the light from the second window facing Caitlin to provide dramatic facial highlights and rich shadows. With creative latitude, he could have altered the light to change the feeling. The artist wanted to reemphasize that the viewer only knows what he is told, via the painting. The artist only has to make it look* right.

If there weren't a second window, the artist would have used a lamp to get that light on Caitlin's face. If he wanted to suggest that light was from a window, he might have made the colors cool. If it were coming from a lamp, it would cast a reddish-yellow light.

Cat's Paw, 21" × 29", Arne Westerman

Backlighting

If the window is directly behind the figure, the figure is backlit and will appear to be a silhouette. How much the figure is illuminated will depend on the artificial light in the room, or how much is reflected from the window back onto walls and ceilings. For the silhouette look, see the paintings of washer women by Degas. There may be some rim light in which one edge or both edges of the figure are light against the darker shape. Let some of that rim light disappear into the window light. A line or two can always be added later if needed to identify an edge (see *Hilary* on page 25).

Darker figures against a window seem to offer a more dramatic approach, especially where light-struck areas add rich contrasts.

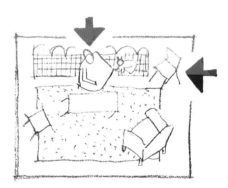

Side Lighting

Add a measure of volume to the figure by having the silhouette modified with a strong or weak sidelight. The light may be created by another window or by a lamp. This allows more facial expression and is still very dramatic.

Sidelight is easy to read and can be quite dramatic. Lose some edges of the light-struck area of the figure into the

Basic People Painting Techniques in Watercolor

lights of the window, or use the outside window midvalues to offer a contrast.

Frontal Lighting

This approach can offer a type of pleasant flat lighting. A figure facing a strong light source with a light window background can be a very charming, high-key solution to a painting. The light source may be another window, strong room reflections or, of course, artificial light.

For a wonderful example of a front-lit painting in a similar vein, see Berthe Morisot's *The Little Servant Girl in the Dining Room*.

Options *Here are two other ways the artist could have changed things. If he chose to have only the window behind the figure to illuminate the room, the model's face would be dark, more of a silhouette, more dramatic. The edge of the hair and bow would have nice highlights.*

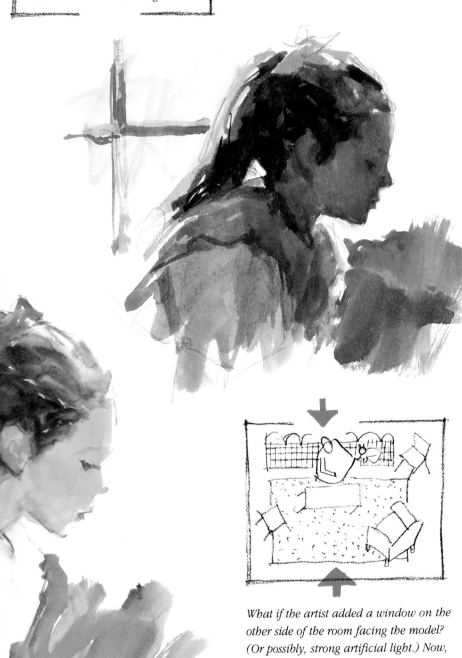

What if the artist added a window on the other side of the room facing the model? (Or possibly, strong artificial light.) Now, the model's face is light. The shadows depend on the angle of the light. The window behind her will give the edges of her face and hair a pretty halo effect.

Bringing Poses to Life by Sketching

Sketching in the center of town surrounded by a cluster of markets, shops, cafés and park benches is a great way to gather interesting ideas for your people paintings. The benches offer a resting place for an eclectic gathering of people: secretaries and derelicts, businessmen and bag ladies. They stand and sit around in quiet contemplation, animated conversation or display a multitude of other actions and gestures.

You can draw in a medium-sized, hardcover sketchbook that slips into your purse or briefcase (the hardcover keeps the pages from becoming dog-eared and helps preserve the drawings). You can use anything from a no. 2 pencil to a felt-tipped calligraphy pen. Your primary interest is the gestures of the people. With a few well-placed lines, try to create a complete sense of the subjects and how they're positioned. These

gestures could be contour line drawings that capture the whole flat shape of the figure and its movement, or you can state gestures by drawing the inside of the body first. Artist Bill Vrscak begins with an outline of the head, then draws the positions and tilt of the shoulders and torso in relation to it, and the rest of the figure follows accordingly. All this flows rapidly—quickness is mandatory when sketching people since they don't stay put for more than several seconds at a time. After you have an initial, head-to-toe contour down, you can go back and add details or make corrections.

You can supplement your drawings of the square with photos. They can help you capture the overall color and feeling of activity. The camera has the advantage of being able to catch large groups of people at once in unusual, animated poses. It records numerous items like

window signs, patterns in clothing and hand-carried objects that you can use as details in later paintings. But don't abandon the sketchbook! Drawing from life helps you respond to your subject on a personal level, especially when drawing people in candid situations.

Combining Images

Poring over your drawings and photos will produce lots of ideas for paintings. Keep your mind open to anything that may cause an emotional response, be it a facial expression, body gesture or the shape of a group of figures. Sometimes, images from two or three photos or sketches may be combined in one painting. Or, the same scene or individual may evolve into a series of different paintings.

Work out a design in a postcard-

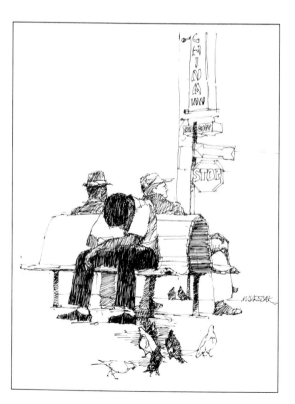

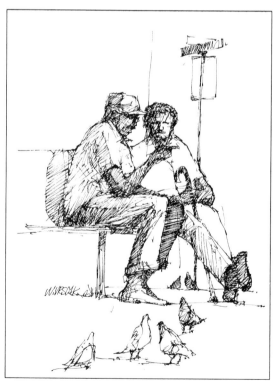

Capturing Contour
Most of Bill Vrscak's paintings spring from the drawings he does in his ever-present sketchbook. As he observes people in parks, airports and other places, he quickly draws contour outlines that capture the whole shape and gesture of the figures.

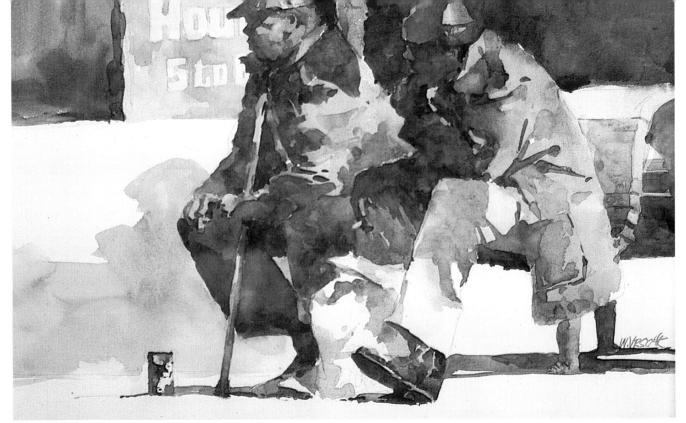

Scene Around Town *To define gesture and personality, first think of your subject as two-dimensional shapes. Then, consider how they fit into the overall design of the page. In* Happy Hour, *for instance, Vrscak was attracted by the strength and consistency of the men's poses. He then emphasized their rounded shapes by using a geometric background and lightened the sign to provide a more dramatic contrast to the man's head.*

Happy Hour,
14" × 21"
Bill Vrscak

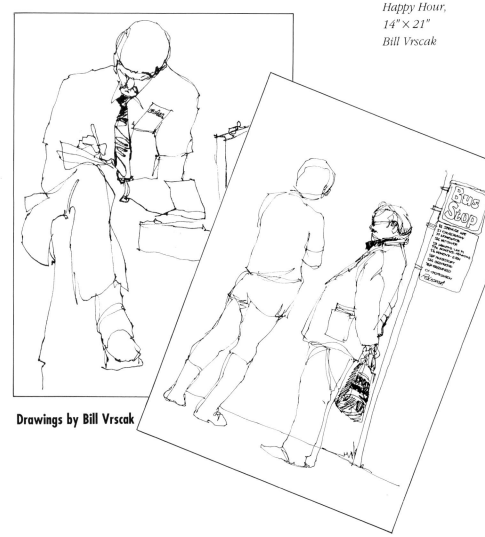

Drawings by Bill Vrscak

sized, black-and-white sketch. Eliminate any nonessential images and enlarge or reduce, add or move any elements that may help you make a more direct statement. Figures may be thought of simply as two-dimensional shapes, and should meet all the requirements that go into producing interesting shapes: variation in contour, clear readability and lost and found edges. Figures almost always represent positive shapes and must relate well with surrounding negative areas. You can insert other elements of the square—street signs, refuse cans, shopping bags—into the drawing to help establish a focal point or to create a directional emphasis across the page.

Bringing Poses to Life by Sketching

Developing the Composition

Sometimes the composition springs from the abstract pattern of values and colors that occurs naturally in a photo. For instance, in drawing *A*, the bright sliver of sunlight coming from the left side is a strong directional element that leads the eye to the group of figures highlighted against the dark background. It also helps to add some motion to what might otherwise be a static arrangement. Drawing *B* is based on a horizontal grouping of small contrasting shapes of local color and value. The visual activity in this area is accented by the large, surrounding areas consisting of darker values.

Drawing A: Strengthening the Pattern *The artist sometimes bases paintings on the abstract pattern of lights and darks in a photo taken on the square. Here, the sliver of light pulls the eye strongly to the group of figures highlighted against the dark background. The light also adds motion to what would otherwise be a static arrangement.*

Drawing B: Finding the Design *Although the photo looks like a confusing jumble of people, the arrangement of lights and darks provided an effective design for a painting. The horizontal figure grouping is rich in value contrast and local color, so the artist focused attention on that by quieting the rest of the design with larger, darker-value areas.*

Expressing Emotion Through Gesture

DEMONSTRATION

After doing a value sketch, the painting process begins with a quick, but fairly accurate contour drawing of the main elements on the watercolor paper. For Vrscak, an incomplete drawing makes for a smoother transition into the painting stage—it allows painting to be more than a coloring exercise. Restricting the drawing to only the essential elements allows him the freedom to develop other areas of the painting in a more spontaneous way.

Vrscak uses a simple layering method, working from light washes to dark. He works over the entire surface at once, covering all of the major areas with initial light washes. He works on hot-press papers because the smooth, staining quality of the surface allows him to work quickly. These smooth-surfaced sheets can seem difficult if you're used to softer, wet-in-wet, blended washes of cold-press paper and rough sheets.

He usually refrains from referring to the photo until all major areas have been established and then he refers to it only for detail information. This allows for more personal involvement in the painting.

He continues working around the entire surface, never getting involved in a particular area for any length of time. After each wash or change has dried completely, he adds progressively darker tones to create a feeling of space and volume. Working from light to dark allows Vrscak to oversee and control the development of the painting.

When he's finished, he evaluates the painting first in terms of its design quality. Then, he asks questions about the emotional attraction of the work. Does the figure bring a living presence to the painting? The design and technique should work together to bring a character to life.

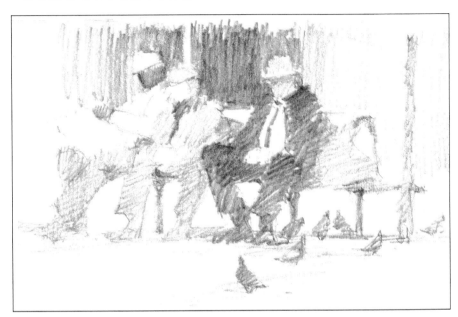

Step One

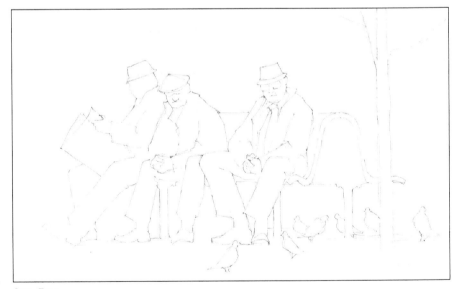

Step Two

Step One
Set Up the Values

The value sketch is an opportunity to work out the design and eliminate nonessential details before painting. Vrscak made the figure on the right the focal point by using a darker value for his body and the space behind his head.

Step Two
State Gesture and Proportion

He drew the contour drawing directly onto Arches 140-lb. hot-press paper, rendering it lightly enough so erasures could be made without damaging the surface. This drawing helps establish the correct proportions from the start.

Step Three
Loose, Light Washes

The first washes establish the largest masses and areas of importance. He worked quickly and loosely here, allowing the background and foreground to blend together so the figures would not look pasted on.

Step Four
Deepen Form

In the typical light-to-dark watercolor method, he went into and around the figures with darker values to suggest form. He referred to his sketch to remind himself of the arrangement of values, and darkened one side of the main character to see how this value would relate to the rest of the work.

Step Five
Compare All Areas

Vrscak continued layering color over the whole surface to define form. At this stage, the pigeons seemed a little too dark and prominent, but this would be lessened when he added more weight and detail to the people. Vrscak established the final value on the main figure so he could key the rest of the values against that.

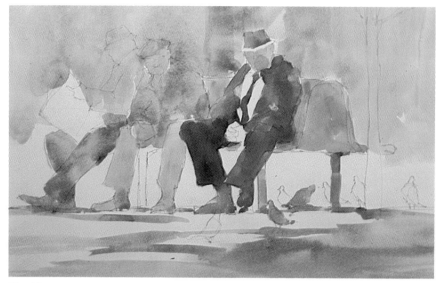

Step Three

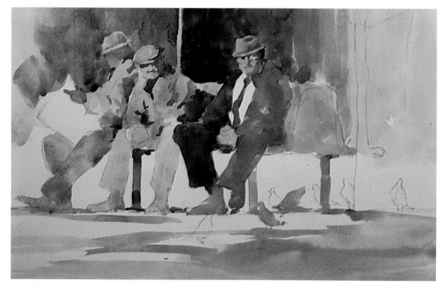

Step Four

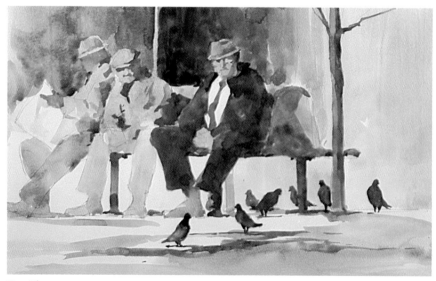

Step Five

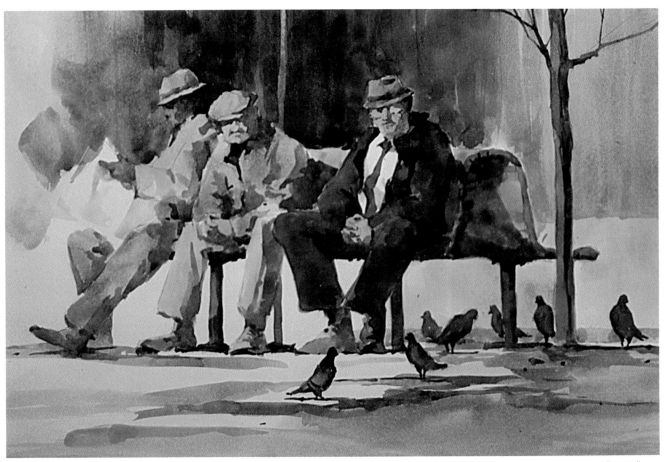

Step Six

Market Square Regulars, 15" × 22"
Bill Vrscak

Step Six
Be Judicious With Detail

With more direct and simple layers of watercolor, Vrscak went into the figures and worked up the detail. The main concern was to add detail and shadow shapes that would create form without breaking the painting into too many separate patches of lights and darks. To strengthen the overall dark shape of the main figure and the shadow behind him, he lightened the rest of the background and the pigeons by washing over them with clear water to finish *Market Square Regulars.*

Unifying With Tonal Value

DEMONSTRATION

Use basic shapes and values to make a clear statement with loose brushwork.

Step One
Sketch in Pencil

The artist believes she makes too many adjustments to start right on watercolor paper—erasures would mar the surface and create unevenness. Also, if the painting isn't successful, the same drawing can be transferred to another piece of watercolor paper.

Step Two
Color Study

Working out the composition, the artist did a color study on a quarter-sheet of watercolor paper. The exercise was useful—after seeing the result, she realized there wasn't a large enough light area on the face of the younger man to make it the center of interest. She angled his face differently in the large painting so it would catch the sun better.

Step Three
Wet-Into-Wet

The artist wet the whole paper with a 1½-inch flat brush (except where she wanted whites), then dropped in color. The result was a high-key version of the completed painting. This first dark wash on the glasses and background added definition.

Step Four
A Balancing Act

Developing the painting was an act of balancing one darker value with the next. For instance, after painting the dark in the foreground man's face and hat, she needed to balance the page by painting midtones on the other man's jeans and hat, and by painting the glasses darker.

Step Five
An Eye on the Whole

The artist continued to apply darker washes, unifying them wherever possible. Although the watercolor is applied freely and has an aqueous look, the value pattern is always clear. The large shapes that organize the painting still control it, and the artist combined areas of similar value when possible for large, unified shapes rather than a spotty value pattern.

Step Six
A Color Change

The red collar and cuffs in the last step didn't contribute to the piece, so the artist painted over them with a combination of diluted gesso and Cobalt Blue pigment. The complementary color works much better with the oranges in his face and the background. By glazing most of the whites in the left-hand figure, the focal point was strengthened.

Step Seven
Bringing It Together

The background still seemed too busy, so the artist unified it with diluted gesso and Raw Sienna. She also glazed over the white shirt to emphasize the light on the shoulder and put a glaze over the light on the lower sleeve. She darkened and grayed the background around the brown hat.

Step One

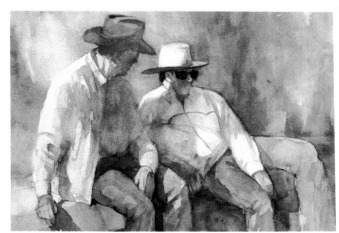

Step Two

Step Three

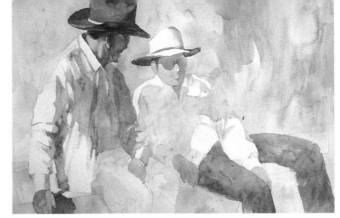

Step Four

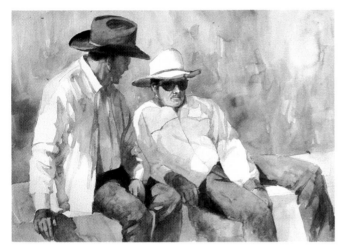

Step Five

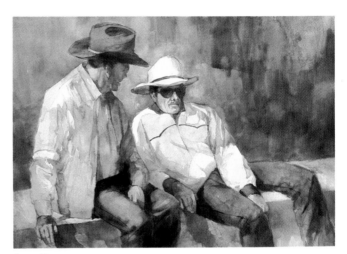

Step Six

Step Seven

Sage Advice, 21½" × 24½", Barbara George Cain

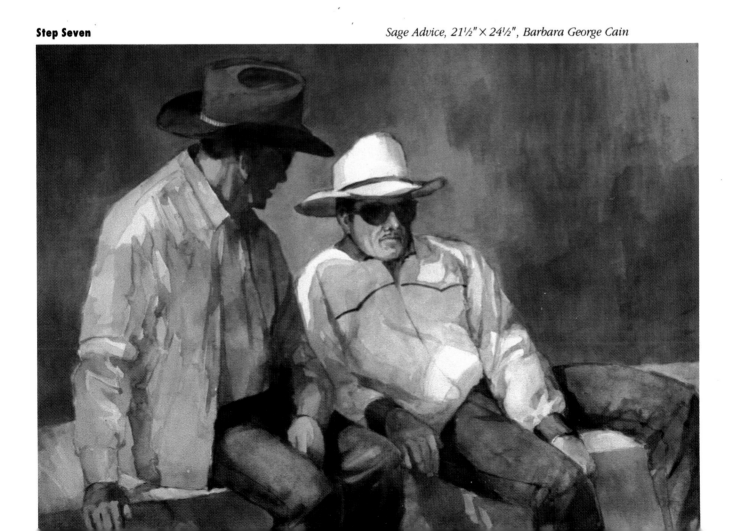

Creating Tonal Value

In *Sage Advice* (page 37), you can see how the artist concentrated on the large masses and shapes, losing edges, combining lights and darks, and uniting as many areas as possible. For instance, the dark of the hat is tied to the dark of the background and the jacket and shirt are unified into one more or less light shape.

By applying successive layers, the values move from light to dark. Although you're working with a general structure set up by the first layers, let the watercolor "do its own thing." Leave details until last and omit as many as possible. To keep your painting clear from a distance, accentuate the focal point by having the lightest light and darkest dark meet in that area, as well as creating the most detail and the strongest color contrasts there. Avoid placing very sharp contrasts of color or value at the edge of the painting, as this leads the eye out of the work. Continue to lose edges where you want smooth transitions and combine lights or darks wherever possible for large, easy-to-read shapes.

Although a full range of values will be included in your paintings, your dominant value—occupied by the largest amount of space—is in the midtones. The light to middle values are where the most beautiful color is usually found.

After you paint the basic values in place, they usually need to be adjusted. Some artists do this with glazes, because these create a soft transition between the lightest values and white.

Even at this late stage, you can make changes in colors, shapes and values with the help of acrylic gesso. In *Sage*

Keeping the Initial Splash *The initial wet-in-wet wash is visible in the light areas of David's Friends. The artist wanted to keep the spontaneous, watery look of the paint visible in this finished piece, so she unified the figures with transparent darks in the background. Unlike the shadows of the chairs in* David, *left, the artist minimized them here so as not to detract from the main focus.*

David's Friends, 22" × 30" Barbara George Cain

Taming the Whites *The artist usually glazes down the whites with a few layers of transparent color to ease the transition between the pure white areas and the middle values. In* David, *she added numerous glazes to the shirt to bring it to the appropriate color and value. Only a very small area is actually white.*

David, 22" × 30", Barbara George Cain

Basic People Painting Techniques in Watercolor

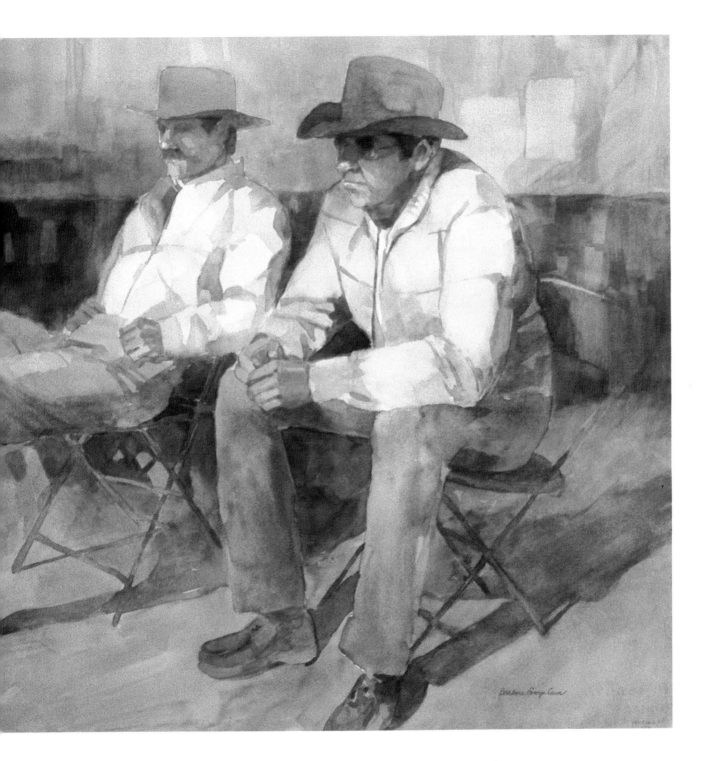

Advice, for instance, the artist didn't like the original red hue of the collar and cuffs, and used a mixture of Cobalt Blue and diluted gesso to change it. Using white acrylic paint for changes like these will leave distracting brush marks under the surface of the work. To mix the Cobalt Blue and gesso, the gesso was diluted enough to create a thin, smooth layer, then the watercolor pigments were mixed into that and painted over the area to change. To obliterate the old color, it takes a few layers of gesso. Another advantage of using gesso is that its smooth surface allows colors built over it to be easily lifted and changed.

In making all of these adjustments on your canvas, your goal is that as your paintings become more spontaneous and free, they will also become more telling as combinations of exciting colors, textures, lines and shapes. The challenge is for the content of your finished painting to evoke a feeling or mood, rather than being simply a design or a portrait.

Dark Against Light
DEMONSTRATION

When artist Stephen Scott Young thinks of value in a painting, he thinks of extreme darks contrasted with extreme lights. He picks subjects in which the contrast is paramount, often black-skinned figures against sun-drenched fences and buildings.

He lives in Florida and travels to the Bahamas for subject matter. He explains, "The light in the Bahamas is such an intense light, it's almost an electric shock to see it. The challenge is trying to keep that feeling."

At times the contrast is so strong that he has to tone it down to make the painting work. Sometimes the colors, too, need toning down in that light—greens in that natural setting can look garish. He will adjust any values or colors to create the overall effect he intends.

He says, "Paintings are paintings; they're not what I see in front of me. It's impossible to re-create nature. That frees me to paint paintings and not try to paint what is really there. If you try to make it look too realistic, you kill it off."

What is ironic is that even with not trying to re-create nature, Young's paintings are so powerfully realistic that people find it difficult to believe that they are watercolors.

He starts with value. He sees value before line and uses the division of value shapes as the basis of his compositions. He says he learned to paint light and dark by copying Rembrandt in water-color.

Step One
Thumbnail Sketches

The artist begins with thumbnail sketches in his sketchbook to develop the composition.

Step Two
First Watercolor Study

He often does full-size watercolor studies before attempting the finished painting. Sometimes, he says, the studies are better than the painting because they are looser and fresher looking.

Step One

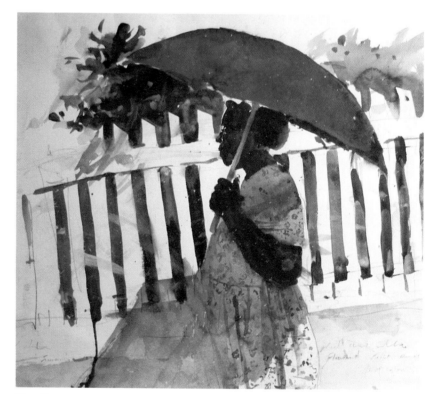

Step Two

Basic People Painting Techniques in Watercolor

Step Three
Second Watercolor Study

Here he changed the size of the figure's hand and arm and the angle of the fence. By the end of this study he had also decided that the red umbrella was too overpowering for the rest of the composition.

Step Four
Third Watercolor Study

He made the umbrella white and added the latticework in the background. Now he is ready to begin the final painting.

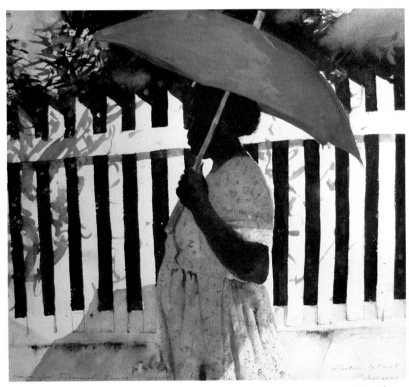

Step Three

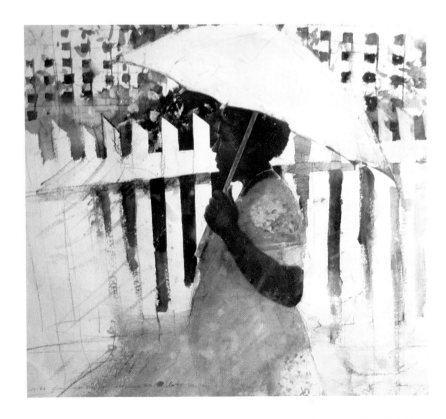

Step Four

Step One

Step One
Dark Values

Young begins by establishing the dark values of the face and the upper background. He uses mostly transparent watercolors, but with 15 to 20 glazes, even transparent paint begins to look opaque. He lightly washes in the shape of the arm and hand and extends the dark values of the background.

Step Two
More Dark Values

He darkens the arm and adds the underpainting for the dress.

Step Three
Dark Against Light

In the finished painting you can see the powerful contrast of light against dark that he began to lay out in the first thumbnail study.

Step Two

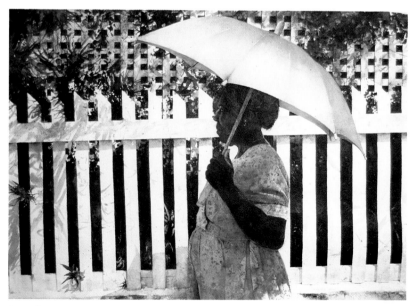

Step Three

White Umbrella, 21" × 30"
Stephen Scott Young

Basic People Painting Techniques in Watercolor

Contrast *The dark-skinned girl in this painting stands out powerfully from the light and light-to-medium values that fill the rest of the composition. The artist creates the mood of isolation for the figure with the extreme contrast.*

Red Ribbon, 23½" × 23½"
Stephen Scott Young

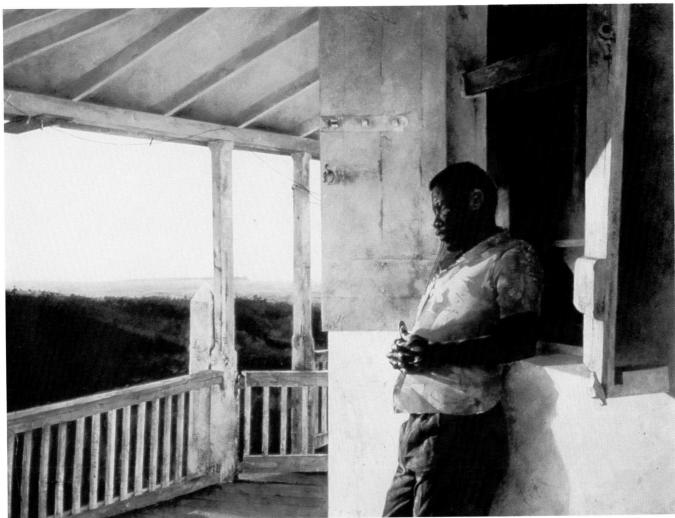

Castaway, 15" × 22", Stephen Scott Young

Negative Space *The artist shows how the negative space in a figure painting can be as vital a part of the composition as the figure. He makes the background interesting by placing light against dark shapes and textured against smooth shapes.*

Composing Your Painting

"Chunking" Figures Together

DEMONSTRATION

W hen your figures are going to be used simply to flavor a scene, try to avoid any kind of real detail. The figures at that point should be suggested through heavy emphasis on gesture, or they should just be "chunked in."

Step One

The artist has made a careful drawing and has started the painting by chunking some blobs of loose color on the background figures and scrubbing some color into the floor and to the right edge of the painting. Some of the background color is washed into the fleshtone. One concern is how to make the stretching dancer interesting and obvious as the focal point. Some whites will be left around her head.

These are the rough and color sketches for Carnegie Studio. *Figures reflected in the mirror have been massed into a single shape as a background. The artist added the figure to the right to connect her dark costume to that of the stretching figure and to create a new shape.*

Step One

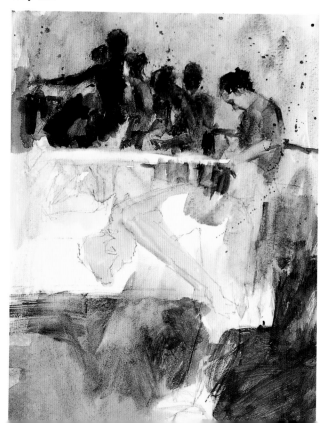

Step Two

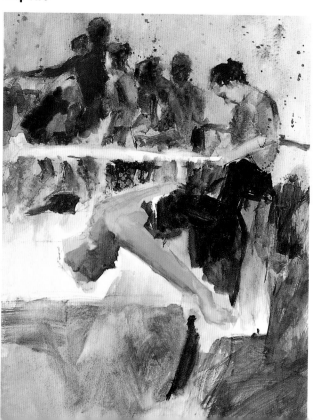

Step Two

The artist gives the central dancer a deep red on the face, deepens her fleshtone, builds the dark of her costume, and lets it flow into the standing dancer, then out. He does some carving on the background figures by wiping out small lights. Also, he works some color into the costumes and adds Cerulean Blue and Gamboge Hue to the floor.

Step Three

The artist thought this painting was done until he saw a slide of it projected to a class he taught. He had left the ballet barre white. When he saw it enlarged, he realized how much attention it drew away from the focal point.

Step Four

The artist scrubbed in some more blue and the ballet barre disappeared. Notice that with that darkening effect, the artist also pushed back the reflected dancers and increased attention to the main dancer.

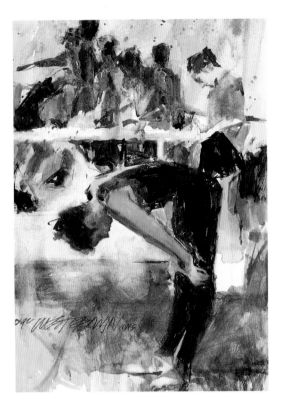

Step Three

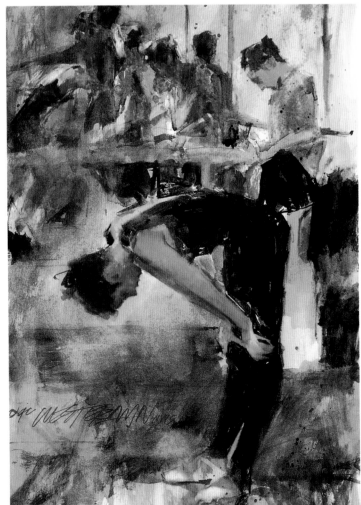

Step Four

Carnegie Studio, 14½" × 10"
Arne Westerman

Painting a Face With Soft Edges

D E M O N S T R A T I O N

Step One

When you paint on the fleshtone, go into the hair, the neck, past the face and into the costume, and do it right. If you want to, you can always pick out the highlights later.

Step Two

Now the shadow side. Cover it all from the hair on down, into the neck and the costume, and into the eye socket on the light side. Notice with just this simple design, you get a real feeling of volume.

Step Three

Now wash some red into the cheeks and forehead, and add Cerulean or Manganese Blue around the jaw and chin, wetting the area with a hake brush first, then adding the color.

Step Four

Darken the area around the nose and eye socket in the shadow side because that's what you see. Brush some color into the shirt, add some touches into the hair and get some red in the ear to make it look natural. Don't fuss too much at this point.

Amateur Approach
Beginners often make the mistake of laying on a fleshtone, stopping at the chin, avoiding the eyes, leaving bare the highlights on the cheeks, nose, forehead and chin.

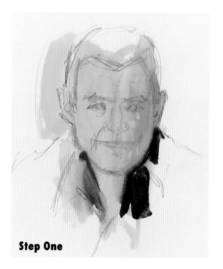

Step One

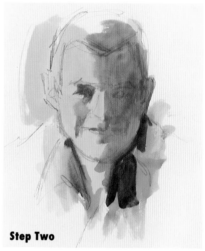

Step Two

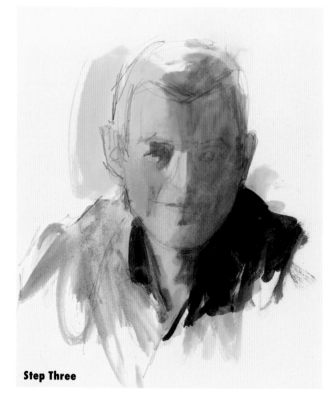

Step Three

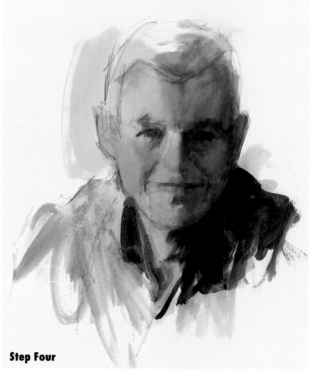

Step Four

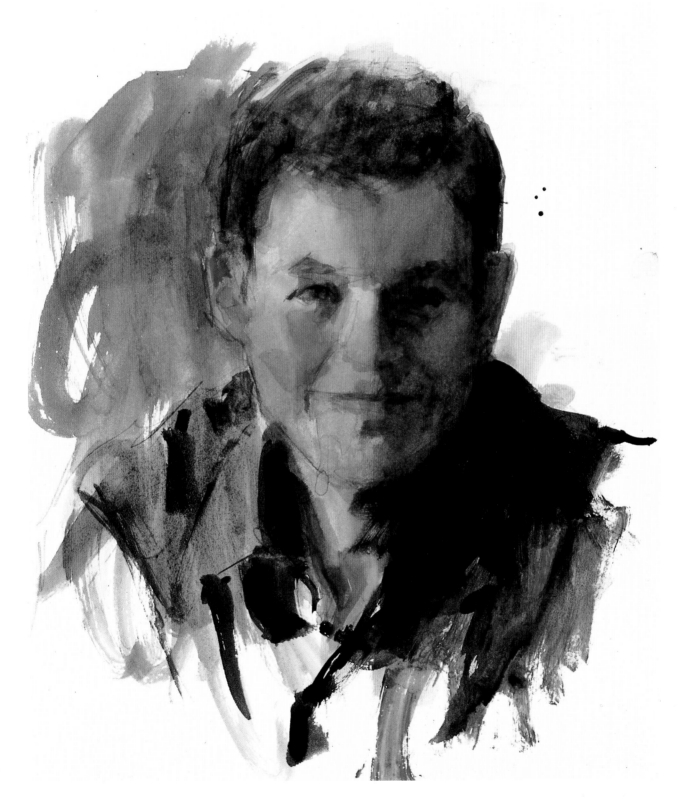

Step Five

Wet the forehead and temples before laying in the hair; you don't want a hard line between the hair and the skin. It would look stark—sort of like a toupee.

Since this is an imaginary figure, pretend the hair is brown and curly. Run some of the hair color past the light side of the face to make a good background.

Painting Incidental Figures

A viewer identifies with figures in a painting. The eye seems to be drawn directly to them. Many watercolorists are afraid to add figures to their work because in the past, some nice paintings were messed up by the addition of unsuccessful stick figures. If you don't know enough about anatomy, you'll feel insecure and afraid to tackle those needed figures.

But wait. Unless you plan to be a portrait painter, the figure is only an *incidental* part of most paintings. It has to be painted well enough to be convincing, but these are not illustrations or portrait or figure studies. So relax. You'll learn how it is done and you will know whether that incidental figure looks right or not.

Worrying about what type of figure to paint and what action it will be involved in can be very frustrating, so take another approach. Simply make a few marks and let the marks *suggest* what the figure will be doing. Don't say, "This figure *will* be doing such and such." The approach is to say, "This shape *makes me think* of a figure doing so-and-so." That basic difference in attitude makes painting the figure much more fun.

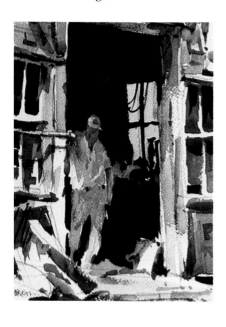

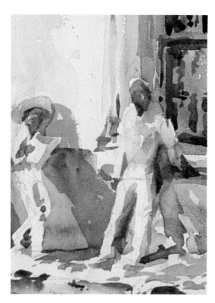

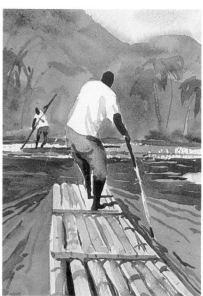

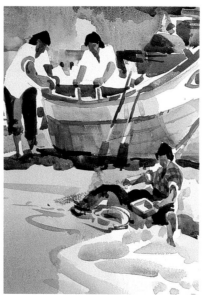

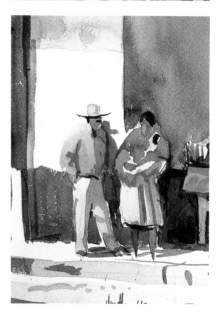

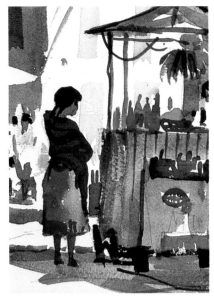
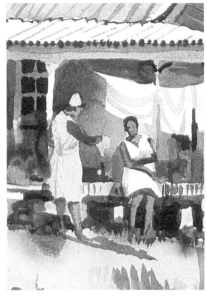
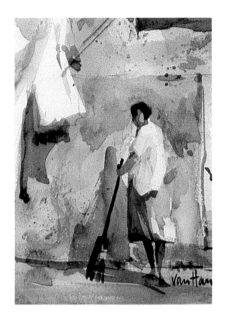
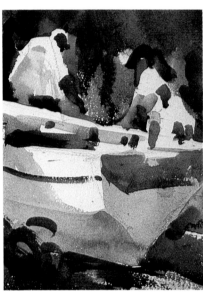
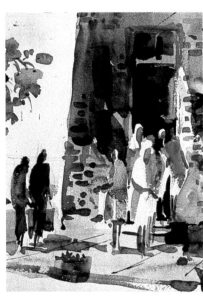
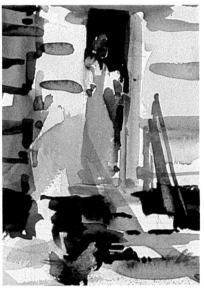

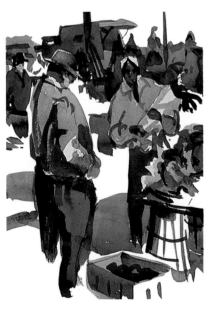

Creating Fun Figures the Easy Way

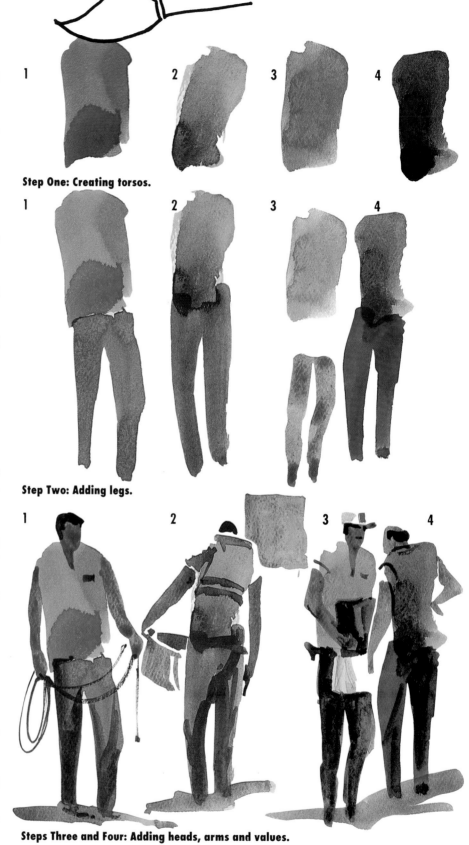

Practice creating a few figures before going to the actual watercolor paper. Start off by using drawing paper with a smooth surface and a no. 8 or no. 10 round brush.

Step One

As the brush diagram suggests, use the side, not the tip, of the brush to obtain the strokes displayed at the top of these pages. Make your strokes about this same size, color and width. Make the mark with one stroke. Don't worry about making it "perfect." You are doing the upper torso of the figure. Give it some bulk and angle the stroke a little to avoid the ramrod straight stick figure.

Step Two

Next, gravity comes into play. That figure should not look as if it will topple over, so place the pant legs where they will balance the weight of the torso. Use the vertical edge of the paper as a comparison guide. These marks are still made with the side of the brush, but a bit closer to the point. Extend those legs longer than you feel they should be. For a female figure wearing a skirt, add a skirt shape and use Burnt Sienna for the legs. Just taper them to a point. Don't worry about feet.

Legs do not necessarily have to be connected to the torso. The third figure from the left could be wearing white shorts for instance. In the sixth figure, some blue strokes were added to suggest shadow areas on a white skirt. Some torso color was also lifted from that figure to allow the head to be inserted. Note also that figures three and four and seven and eight are placed closer together. It is better to have figures overlap than to stand isolated.

Step One: Creating torsos.

Step Two: Adding legs.

Steps Three and Four: Adding heads, arms and values.

Basic People Painting Techniques in Watercolor

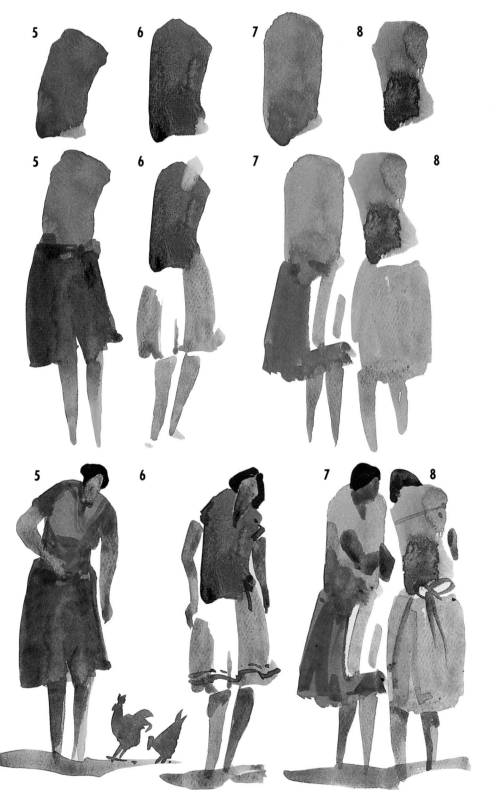

Step Three

Now it is time to paint the head and arms, again using Burnt Sienna. Make the head much smaller than you think it should be. Avoid placing it dead center on the torso. Place it wherever the existing marks *suggest* it should be placed. Does the mark look like the figure is coming toward you or is its back to you? The first one seems to face us, so a comma-like head is placed on the torso, with the tail of the comma suggesting a neck opening. The second figure suggests someone seen from the back; only a small indication of a head is needed since most of it is hidden behind the shoulders. Other heads were added in the same manner. Use the tip of the brush for the arm and leg marks. Place those arms where they feel right. Experiment to see what happens, and remember, you don't need to show every arm.

Step Four

Some darker values are used to add hair, some stripes on the clothing, and whatever props complete the setting. With the first guy, a rope is added. On the second one, the placement of his arms suggests he is carrying something. Note that those shorts on the third person changed into a work apron, and he is carrying some bag or box. The first female figure is feeding some chickens, and so on. Dream and have fun. Note that feet simply disappear into the shadows underneath each figure.

Adding Dark Figures to Your Paintings

After doing several pages of figures, try getting out some paintable acetate as mentioned on page 13 and add some figures to the subject below. Just for fun, two colorfully dressed ladies were added against the adobe wall since this scene was originally painted in New Mexico. Were they gossiping about those artists who came to paint their town?

After your figures are painted on the acetate, move it around to select the best spot for them. Once that decision is made, you can paint those figures right into the scene, using the acetate version as a guide.

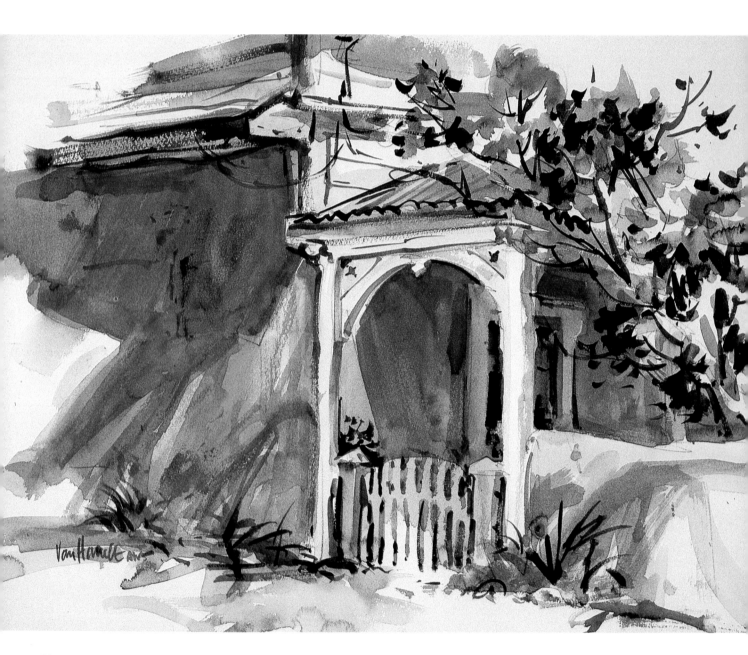

SOME GENERAL THOUGHTS ON FIGURES

Here are a few general guidelines and thoughts for adding the incidental figures to your landscape:

- Avoid action figures such as runners and jumpers. The most successful additions are those figures who just walk, converse or stoop to do something.
- Remember the alternation principle. Place the light figure in the dark doorway and the dark figure in the sunny spot.
- Relate the size of the figure to its surroundings, such as doors and windows.
- Generally, the color used on clothing is much brighter than other areas in the painting.
- Clothing does not *have* to be colored. Some folks wear white.
- Avoid rendering features unless you are doing an illustration or portrait.

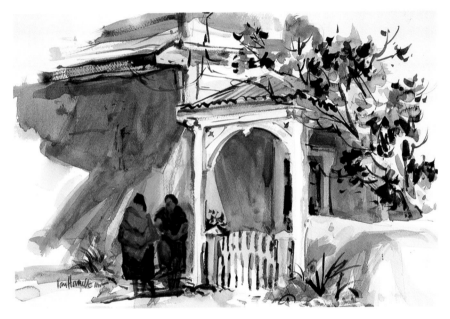

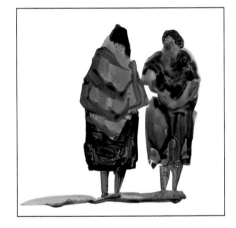

Focal Point *The two figures add a focal point to this scene.*

Adding Light Figures to Your Paintings

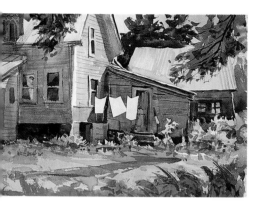

As seen in the previous demonstration, adding figures over light backgrounds is easy to do on acetate. Adding *light* figures over dark areas is a bit more complicated. Suggested changes in this backyard subject, below, will show how it is done. The scene is not unlike an empty stage set. Everything is in place, but the actors have not as yet appeared. How can this subject be enlivened?

Breaking up the lean-to shadow with laundry shapes, as seen in the smaller version, at left, is one way to bring light into that dark area, but it creates another problem—an unfortunate focal point right at the center of the painting. A figure added at a better place will pull the eye away from the painting's center. The laundry will remain in the center of the work, but the figure becomes of first importance; the laundry is cast in a "supporting artist" role.

Since the background is dark, a light figure must be added for contrast. White paper was used, and a tissue was roughly torn and crumpled in the ap-

proximate shape of the figure and placed underneath the acetate, as can be seen in Step One. These crumpled pieces of tissue are referred to as *ghosts.* At this stage of the addition the exact shape of the figure is not important, but only where it is placed, so a general ghost shape will do.

In the Step Two close-up, the silhouette of the ghost shape is changed into the needed figure. Since it is quite a wide shape, two people could actually be made out of it by overlapping the figures. It certainly seems reasonable that a neighbor came over to chat with the lady of the house. The approximate background color is painted on the acetate by cutting into the ghost shape at the shoulder, which creates the head. Some more adjusting of the silhouette takes place at the waist, but note that the feet are practically nonexistent.

In Step Three, the white shape is broken up with blue shadows and the face, hair and arm colors are added. Finally, by placing a piece of paper underneath

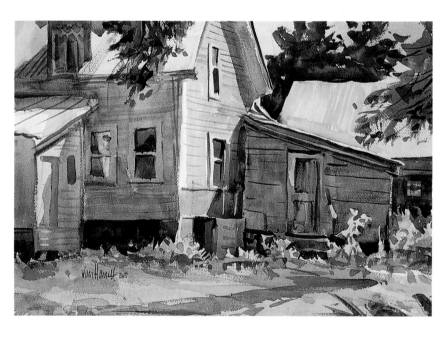

Basic People Painting Techniques in Watercolor

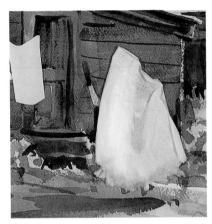

Step One

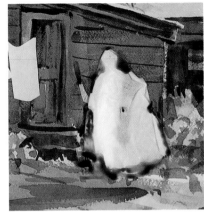

Step Two

the acetate, Step Four, you can see what has happened to shape the ghost into the two figures. The resulting changes, below, are just on the acetate. The actual painting has not been touched. Therefore, should you change your mind and find this is not the right finishing touch, another approach can be explored. If you are satisfied with the effect, the general figure area has to be masked and the paint removed. You can then re-shape the figure by repainting the background.

Step One

A tissue was torn and crumpled into the shape of a figure and placed under the acetate.

Step Two

The silhouette of the "ghost shape" is changed into the desired figure.

Step Three

The white shape is broken up with color. You're still painting on the acetate.

Step Four

By placing white paper under the acetate, you can see what has happened.

Focal Point

The addition of figures enlivens a dark area and adds a focal point. These changes are just on the acetate.

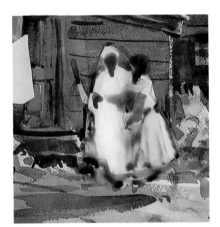

Step Three

Step Four

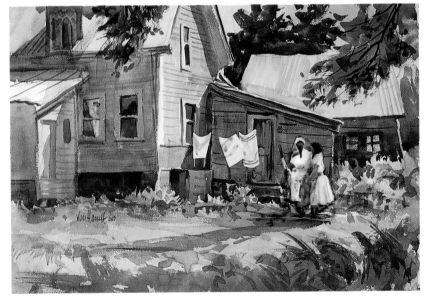

Focal Point

Keeping Your Figure Options Open

On location, when faced with a subject that includes a large dark area, it's a good idea to anticipate the later addition of some light figures by leaving ghost-like shapes, as shown at right. These shapes can easily be modified into figures by reshaping the background a bit and adding convincing details as seen in the close-ups on the left.

In an opaque medium, the white figures could just be added on top of the dark paint. In watercolor, you have to think ahead and save those precious whites. The more you paint—and the more you get into trouble—the more you learn to think ahead and keep your white options open for later development. And needless to say, the early warning system of the pattern sketch alerts you to just *where* to leave those whites.

La Iglesia offers an interesting twist to the saving of white spaces. This painting was started on a Sunday morning in a sleepy Mexican village. The subject was selected because of the interesting textures and shadow play on the church entrance. Those dull and dark rectangular openings *had* to be broken up and made more interesting by adding some figures in front of them. Being sensitive to the possible reaction of real-life bystanders, however, the artist left some undeveloped white spaces, as seen below, and the painting was finished in the studio.

In the close-ups, you'll see the white shapes were first broken up with some blue washes, signifying white clothing in shadow. Since the shadow of a nonexistent figure had already been established at the right entrance, her darker skirt was added at the same time. Some lighter areas were lifted out of the very dark interior to relieve its heavy feeling.

Next, faces, hands and color accents

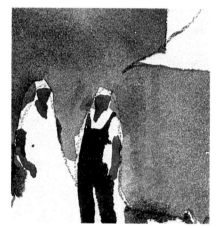

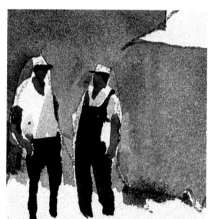

Step One

Basic People Painting Techniques in Watercolor

Step Two

were added and more figures were lifted out of the dark interior color. Still faced with the very definite separation caused by the two door openings, those dark shapes were linked together by adding the lady in black in front of the church.

Those finishing details looked good, but as the original version shows, everything was quite centered. The *L*-shaped mats solved that problem by eliminating most of the right side of the painting. Too bad, but the result that is pictured below places the grouping of figures at the best spot in the painting.

Step One

Underdeveloped white spaces.

Step Two

Washes.

Step Three

Details.

Step Four

The finish.

Step Three

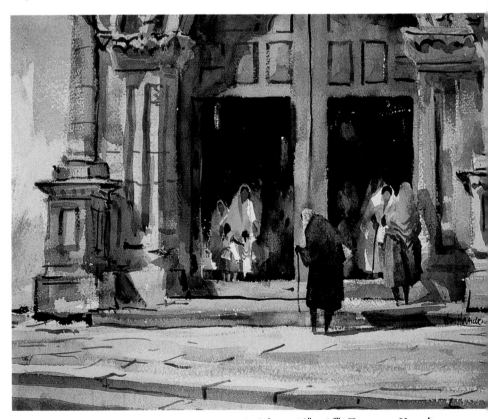

Step Four *La Iglesia, 12" × 16", Tony van Hasselt*

Painting Figures by the Ocean

D E M O N S T R A T I O N

These shrimp boats work up and down the Florida east coast, remaining fairly close to land. Occasionally, one will lose power or have some other problem and end up on the beach. The *Patricia M* was one of these. She came ashore on a resort beach and attracted an audience of beach-walkers and swimmers, as well as becoming the subject of many of the artist's sketches and several paintings. This demonstration was developed from the artist's memory of the scene.

The Drawing

Any subject as complicated as this requires a considerable amount of work in the drawing stage. For this reason the drawing was done on a large tracing pad. There were many trial and error changes along the way, and working on the tracing pad saved the wear and tear of erasures on the watercolor paper.

The placement and sizes of the figures were determined by using the perspective method. It is only necessary to establish three or four key figures, and then, using these as a guide, the others can be easily placed and sized by eye.

When finally satisfied with the drawing, the artist blackened the back of the tracing paper with a stick of graphite and transferred the drawing to watercolor paper.

Step One

Since the background of the sky and ocean were to be painted very freely, using big brushes, the artist decided to mask some of the detail. Without masking, the masthead and crosstree, as well as the bow of the boat with the standing figure, would have been hard to work around while painting rapidly with a 1½-inch brush.

The ocean was also painted freely with a no. 10 round brush; any parts of figures that have the ocean as a background were masked with Winsor & Newton's Art Masking Fluid.

This particular sky, to be successful, was painted in three fast stages, with the final stage being done before the first stage dried.

The first stage was a band of Yellow Ochre plus a touch of Cobalt Blue along the horizon. This was followed by a gray made of approximately equal parts of Ultramarine Blue and Burnt Sienna. Gray formed the shadow and undersides of the cloud masses.

Next Winsor Blue was used for the blue sky, defining the tops of the cloud shapes, and then quickly with a very light touch the artist pulled the Winsor Blue down through the two, still wet, previous stages.

For the foreground sand, Yellow Ochre neutralized with a small amount of violet was used. This whole first stage, sky and foreground, was painted with the 1½-inch flat brush.

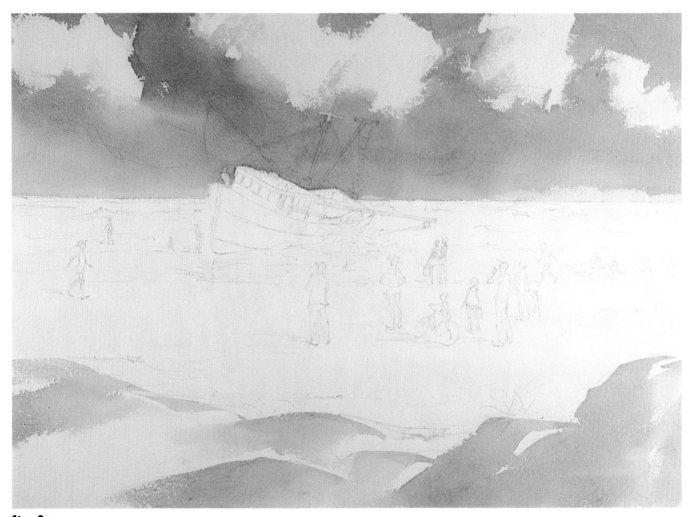

Step One

Painting Figures by the Ocean

DEMONSTRATION

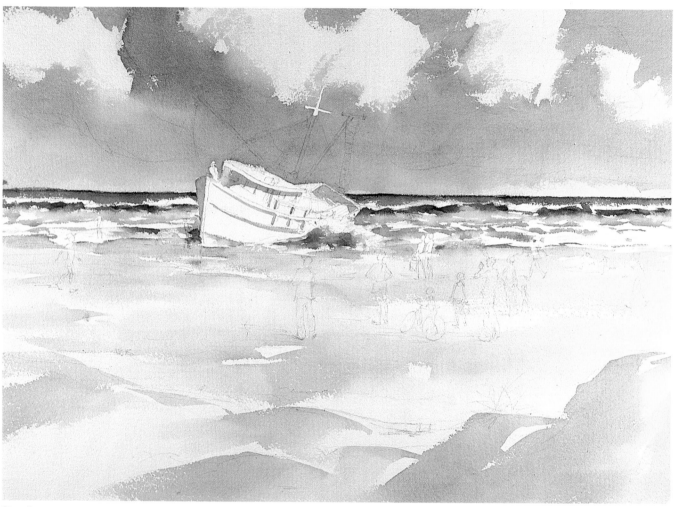

Step Two

Step Two

At this point, the sky was dry enough for paint to begin to be applied to the ocean, starting with the horizon. The color along the horizon is Cerulean Blue with a little Winsor Green and a touch of Payne's Gray. After the horizon was painted, the ocean was brought forward toward the beach, allowing the roughness of the paper to serve as the foamy edges of the surf. Adding Yellow Ochre to the mixture gave a yellower green to suggest the shallower water. Toward the edge of the beach quite a bit of white paper shows, representing the foam.

As soon as the ocean was dry, the masking was removed. With a wash of Cobalt Blue, plus a touch of Burnt Sienna, the shadow pattern indicating the form of the hull and cabin was added.

Basic People Painting Techniques in Watercolor

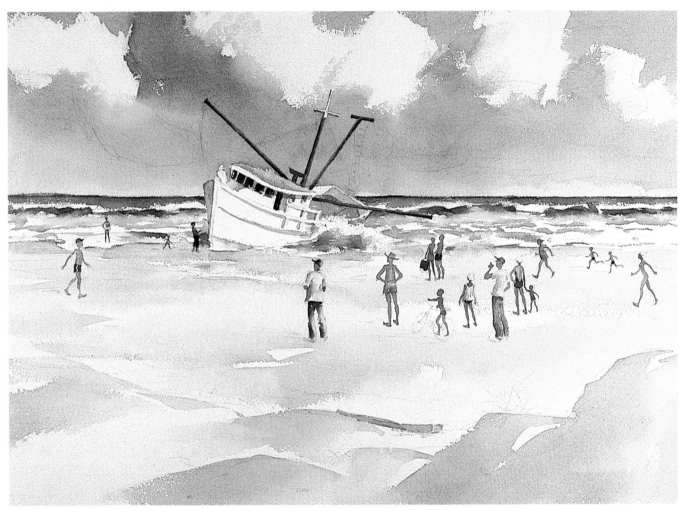

Step Three

Step Three

All the broad, big-brush painting was finished, and with it most of the chances of things going wrong. The sky, in particular, wouldn't lend itself to any correction, and if it hadn't turned out, the artist would have started over.

In working on a very busy scene such as this, it is better not to concentrate on completely finishing the detail of any one area at an early stage, since this will commit you to the same degree of finish

for the entire painting. Often, you will find that the painting has somehow finished itself at a certain point, with less detailing than you might have originally planned. As a result, the painting is better for it. It's the old story of knowing when to stop.

Taking the detail in stages, the artist put in the more important elements of the boat's rigging and some features of the hull and cabin. This meant painting in the mast and booms, the deck, and

the cabin windows and door.

Attention was turned to the figures, taking them one by one, blocking in the fleshtones and the clothing colors. So the fleshtones will be dark enough to give each figure a good silhouette value, Cadmium Red plus a lesser amount of Yellow Ochre was used with a touch of Cobalt Blue. This gives a fairly good suntan color that varies from figure to figure.

Painting Figures by the Ocean

DEMONSTRATION

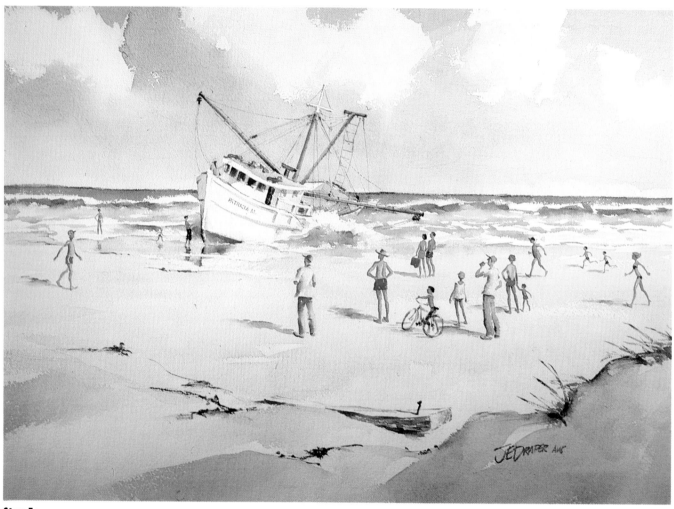

Step Four

Patricia M, J. Everett Draper

Step Four

The center of interest is the shrimp boat with the captain standing in the bow. The artist painted the captain in, with his yellow foul-weather gear, and then added the green paint to the hull bottom and strengthened various other darks in this immediate area.

The figures on the beach were painted with a fairly flat fleshtone. Modeling and strength were added with a darker mixture of the same color. The same was done to the various clothing colors, and shoes, hats and any other detail, including the bikes were added.

Ultramarine Blue plus a little Burnt Sienna and Alizarin adds a cast shadow to each figure. Shadows attach figures to the ground and also point toward the center of interest.

With a small brush the artist completed the boat's rigging and the letter in *Patricia M* on the bow. All that was left was to add some foreground interest by means of the piece of timber, some grasses and the scattered bits of seaweed.

Basic People Painting Techniques in Watercolor

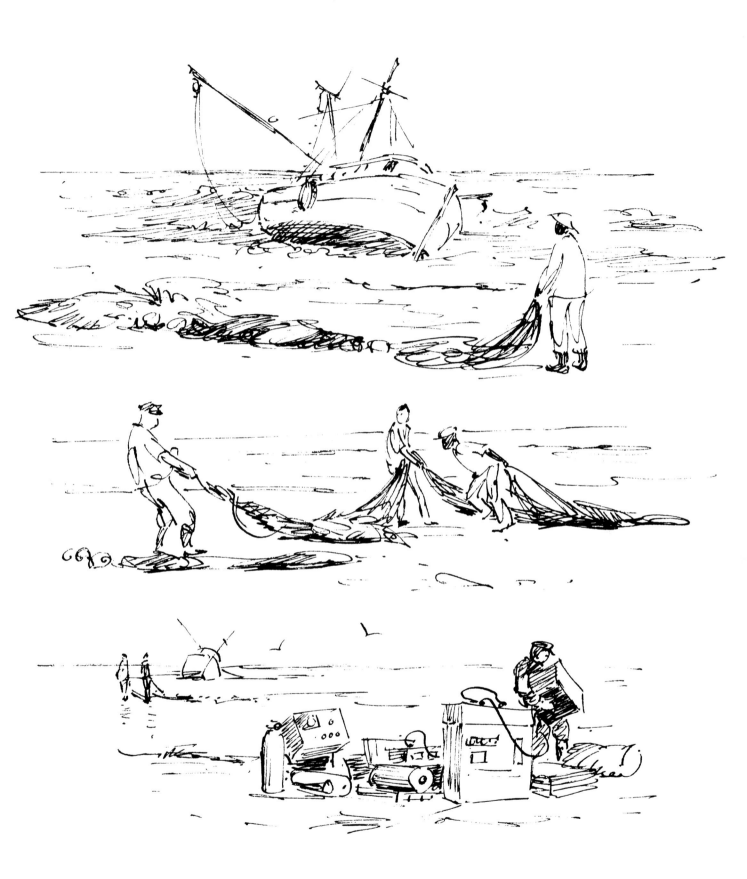

Postscript

They were never able to move the hapless shrimp boat out to deep water again. After all her gear and equipment were salvaged, she was left to break up. Here are a few sketches of the final hours of the *Patricia M.*

Creating a Busy Market Scene

DEMONSTRATION

When including figures in your paintings, you may be working with groups as often as you will with single figures. Groups should be considered as a unit and designed as a unit. Each group should have an interesting silhouette shape and a well-designed pattern of light and dark within this shape. As a whole, it should relate well to other elements in the painting.

On some occasions, the overall shape or silhouette of the group will be more important than the definition of the figures within it. When definition and separation are required, they are best achieved by means of value and color, with value being the most important factor.

Each group should be planned as a composition in itself, with careful attention paid to such things as variety of sizes, shapes and spacing within the outlines of the group. Make sure that the light and dark pattern within the unit works satisfactorily before adding color.

Of several thumbnail sketches, this one was selected to show design and composition for this demonstration.

Basic People Painting Techniques in Watercolor

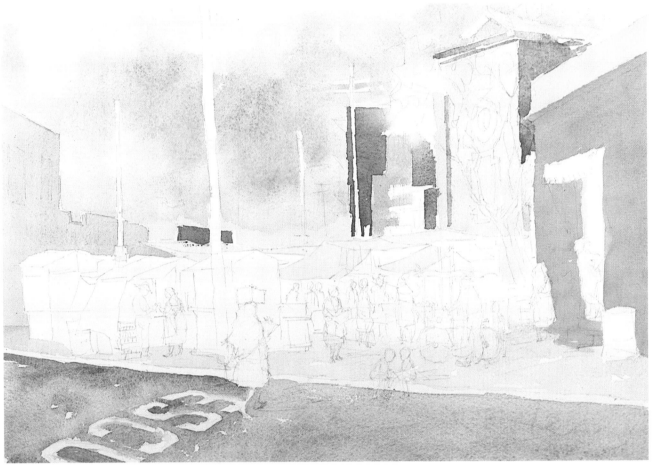

Step One

Step One

After completing the pencil drawing, the artist decided that the white shapes of the overhead tent flaps should be saved. They were covered with masking tape before the painting was begun. Since their shapes were simple and consist of mostly straight lines, the tape was simpler to use than a brushed-on masking medium.

Several areas lend themselves to broad washes of color, so those were added next. This established the basic color and value of the buildings, sky and street.

The street was complicated by the white lettering on it, but painting around the letters posed no real problem. It was a sunny-day scene, so the artist used warm colors on the sidewalk, the street and on the building at the right. Some of the background details of the buildings and the many utility poles also received warm coloring.

Creating a Busy Market Scene

DEMONSTRATION

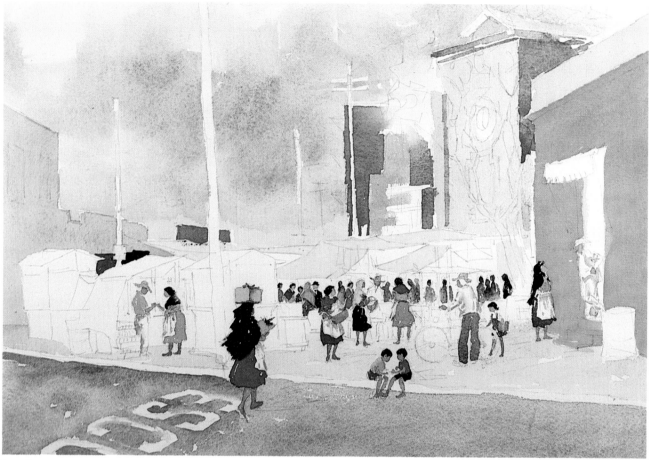

Step Two

Step Two

In the *Patricia M* demonstration described earlier, the artist painted a background tone right across the penciled-in figures, and then painted the figures on top of this tone. Here, we have a different situation because the background was broken up with darks and small color areas instead of a simple, broad wash.

One solution would be to mask the figures. Instead, the painter chose to paint the figures in, and then paint around them, since the background consisted of small, easily controlled areas of color. Another approach would have been to leave negative shapes for the figures.

Although the figures at this stage weren't completely finished, the figure shape was. This included the two boys on the curb, even though they had a light background.

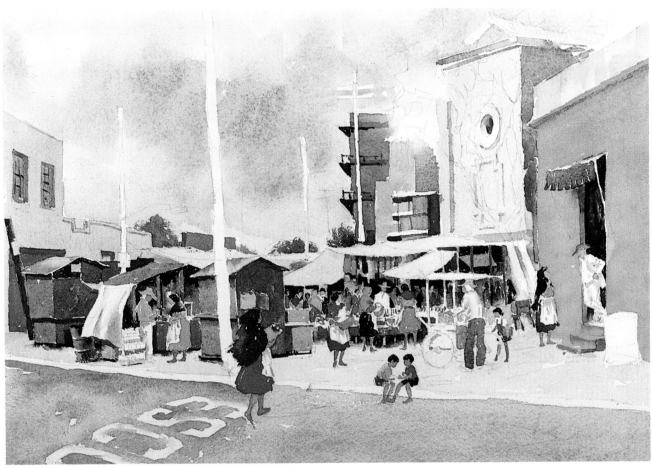

Step Three

Step Three

The utility poles were dark in the actual scene, but the artist felt that they would stand out too strongly in the finished painting. He cut around them when painting the sky, so later they could be painted either light or dark.

Next, the painter began to work on the background behind the figures. First, he spotted in the few bright and light colors on the merchandise tables, and then filled in with the darker values be-hind the figures.

None of this detail, including the figures, was finished at this point. In the final stage, stronger accents and sharpened detail were added as needed.

The booths were painted a harsh, bright blue, which seemed to be the theme color for the whole market. The windows and balconies were added to the buildings to provide some dark accents.

Creating a Busy Market Scene

D E M O N S T R A T I O N

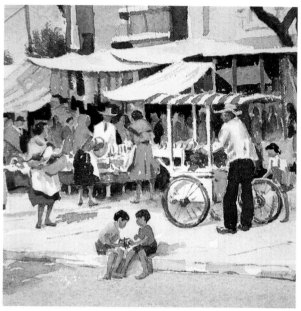

The figure shapes had been established in
Step Two; in Step Four, details of the scene
were clarified and colors refined.

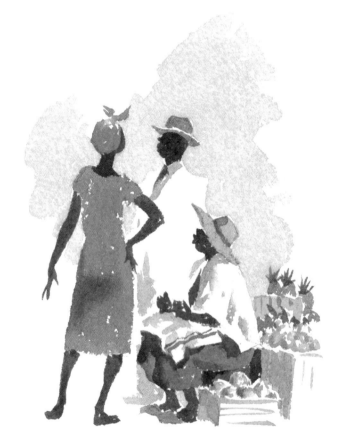

Basic People Painting Techniques in Watercolor

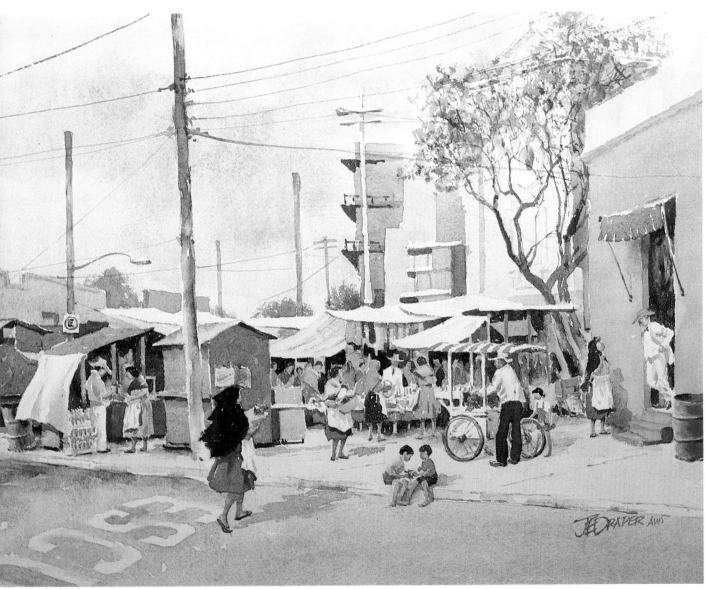

Oaxaca Market, J. Everett Draper **Step Four**

Step Four

At this point, the essence of the scene has been established, but a lot remains to be done.

The artist carefully went over the figures, one by one, sharpening detail, adding darks and brightening a few colors. The shawl of the woman in the center (carrying the basket) was made a light value. The ice cream cart was detailed and red stripes were added to the top.

The utility poles and wires, which add a certain texture and capture the spirit of a purposely busy scene, were put in. When the poles were painted, the values were controlled from light to dark, as needed. The tree added the final touch of texture and color.

Figures on a Bridge

D E M O N S T R A T I O N

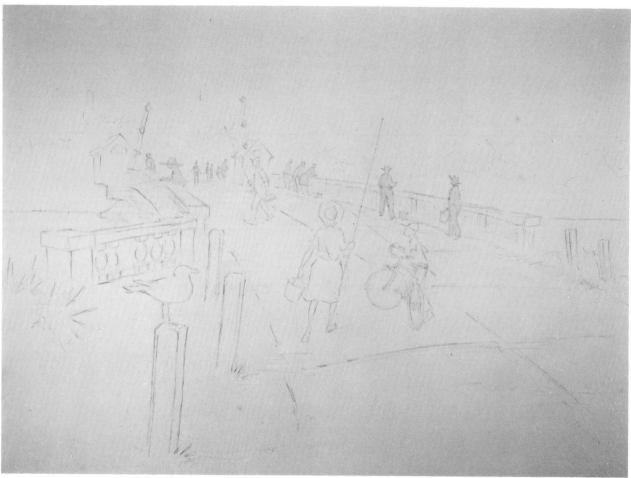

Step One

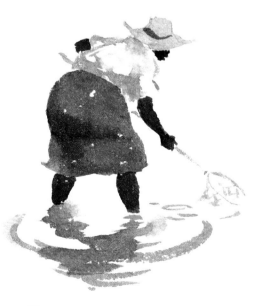

Step One

Bridges are difficult subjects from the standpoint of perspective. This, coupled with the fact that the artist took a number of liberties with the actual bridge in order to improve the setting for the figures, created extra problems. The drawing was worked out on tracing paper before being transferred to the watercolor paper.

Areas were masked where figures were to be placed against the dark background of the distant trees.

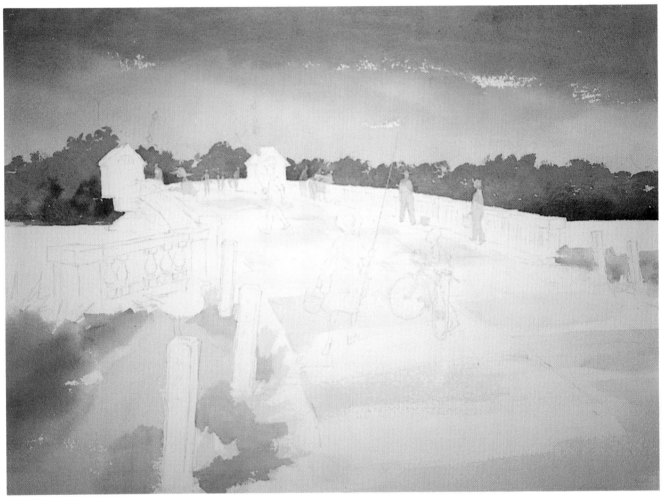

Step Two

Step Two

The sky was painted first, starting with a wash of Raw Sienna with a touch of Winsor Blue along the horizon, and changing to pure Winsor Blue for the upper part. It comes below the treetops, but the artist was careful to soften this lower edge to avoid the possibility of a hard line showing through later washes.

Next, a few light tones were added in the foreground and a few light strokes of gray were placed to indicate the sur-face of the bridge.

By this time, the sky was dry. The background trees were added; the green is a half-and-half mixture of Ultramarine Blue and New Gamboge plus a little Burnt Sienna.

The tree background was painted as a simple, flat wash without detail to avoid conflict with the foreground figure detail yet to come. The side of the brush was used against the rough paper for the top edge of the tree line.

Figures on a Bridge
DEMONSTRATION

Step Three

Step Three

The artist continued to work on the setting for the figures. The bridge required quite a bit of detailing, so this came next. The treatment of the bridge railings was kept as simple as possible, although they were actually rather ornate. The gatehouses were also treated simply, so they wouldn't detract from the figures.

The concrete posts at the bridge approach were painted along with the bridge detail. With most of the bridge defined, the water was painted. The water, which was a brilliant turquoise, adds a bright color note to the painting. Cerulean Blue and New Gamboge were used to achieve this color.

When the water was dry, the masking was removed from the figures. The next stage includes the start of those figures.

Basic People Painting Techniques in Watercolor

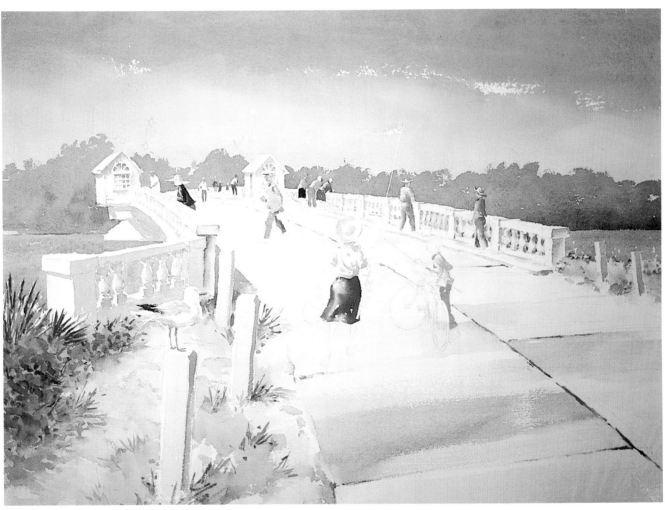

Step Four

Step Four

Using Raw Sienna and Winsor Green for the light greens, and Burnt Sienna and Winsor Green for the dark, the foliage and grass in the lower left were roughly painted. The seagull perched on the concrete post was also finished.

Most of the painting areas surrounding the figures have already been established.

At this stage, colors were blocked in without detail. Until now, the artist used nothing but retiring background hues, but with the addition of these stronger and brighter colors, the whole appearance of the painting began to change.

After the colors were in place, attention was turned to the roadbed, adding the dark streaks across the foreground, indicating the center line and a few other dark accents.

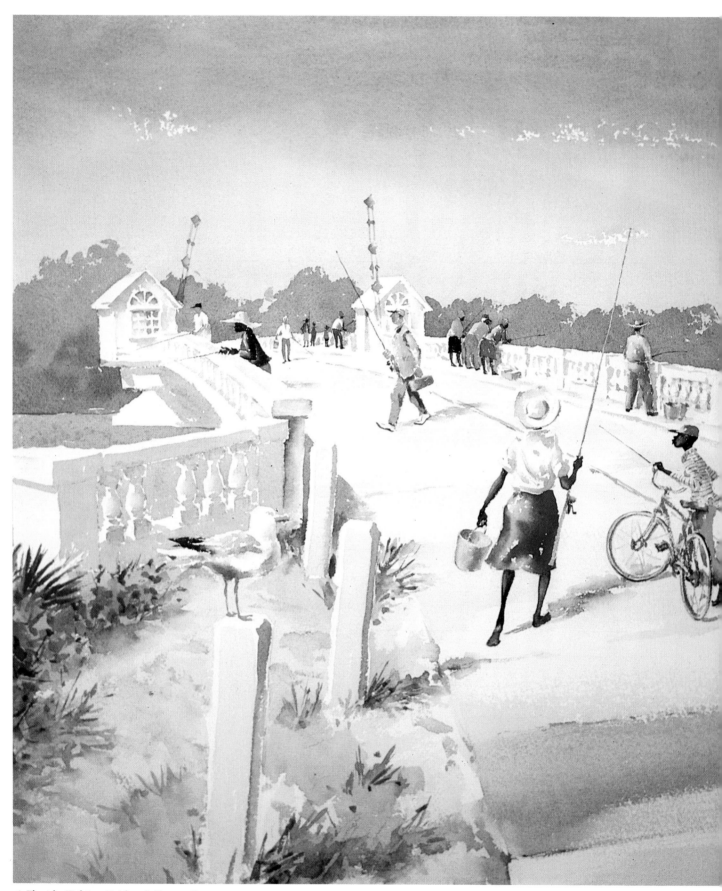

A Florida Fishing Bridge, J. Everett Draper

Basic People Painting Techniques in Watercolor

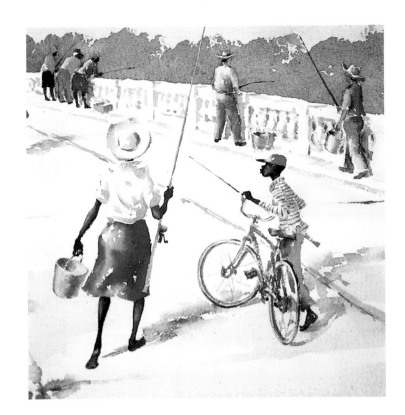

Step Five

This is the finishing or dessert stage of the painting. The figures have been blocked in and the color distribution decided. From here on, most of the work was completing and adding final detail to the figures.

The head of the boy on the bicycle received a touch of Cerulean Blue to give skin highlights. Then the rest was built with equal parts of Alizarin Crimson and Burnt Sienna plus a little Payne's Gray to darken the mixture.

The same procedure and colors were used in completing the foreground woman. Next, the artist touched up the smaller, more distant figures and checked for any missing detail.

The cast shadows of the figures were an important addition. Even though cast shadows have defined edges, they were softened. Any additional hard edges would create a conflict with other detail. One important function of cast shadows in a scene of this kind is to anchor the figures to the ground.

The drawbridge gates and fishing rods were added; the yellow line, a final bit of detail. The painting was done.

Painting Portraits

A good portrait is the result of decisions you make based on really *seeing* your subject. Whether you've decided to paint from life or from a photograph, you must also decide what you want to convey about your subject. Colors, values and lighting can be rendered to express your subject's personality. Look at the photos here of Jon-Marc to observe color, values and lighting.

In the photograph on the next page, Jon-Marc's left cheek is in full sun (toward yellow-orange). The front of his face is turned slightly and is consider-ably cooler in hue. Look above his left eye (*A*). This color is a cool red, and then becomes cooler still as it approaches the shadow side. You can see this cool red again under his left eye (*B*) and near his chin (*C*). The color temperature changes are clearly visible in Jon-Marc's hair. The direct sunlight adds sparkle, and then the color turns to gold approaching the shadow side. It becomes almost Cobalt Blue on the horizontal area near the top of his head (*D*). These same changes in color "temperature" are visible on his neck near where the sunny and shadow sides meet (*E*).

Now look at the shadow side. You can expect to find reflected light along the jawline where the light bounces off his orange shirt (*F*) and at the bottom of his nose (*G*). Look at the beautiful reflected glow on his chest (*H*). The shadow side of his hair is full of color. Can you see blue, green, perhaps a bit of purple?

Last but not least, notice the reflected light under Jon-Marc's left ear (*I*). Ears are a very important part of any face and should be given careful attention.

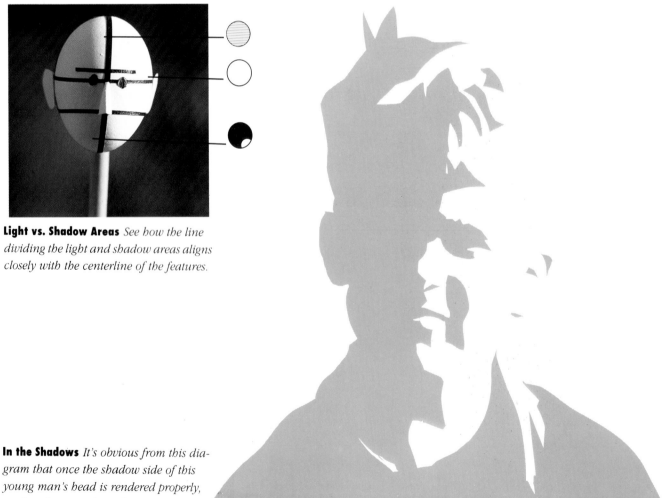

Light vs. Shadow Areas *See how the line dividing the light and shadow areas aligns closely with the centerline of the features.*

In the Shadows *It's obvious from this diagram that once the shadow side of this young man's head is rendered properly, you've almost got it made.*

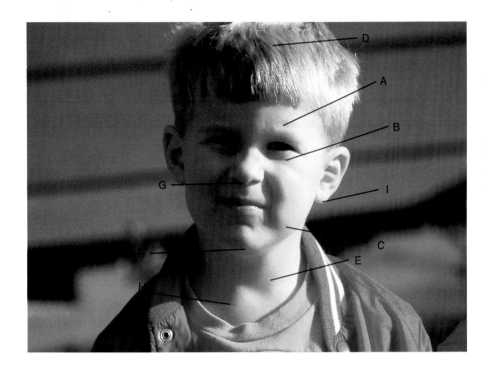

Light and Shadow *By studying the photograph you can discover all the colors in the light and shadow areas.*

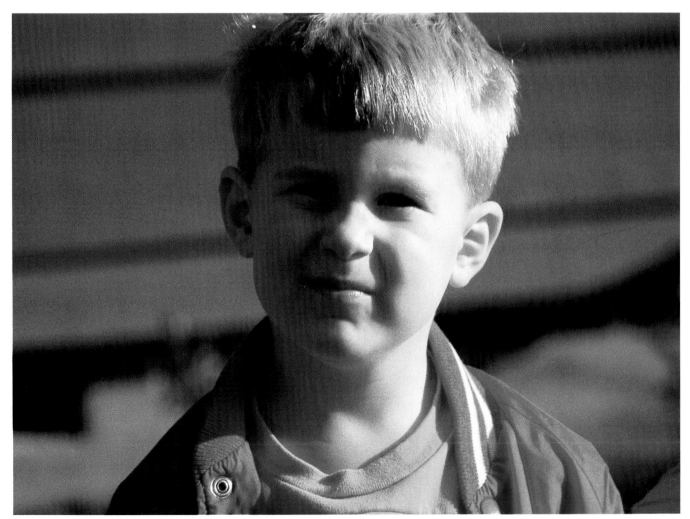

A Photographed Model *Once again, this enlarged photo will help you as you follow the detailed description of the painting process on the next six pages.*

The Final Drawing

The artist wanted to present Jon-Marc as a vignette. There's nothing formal about Jon—he's just fun and the artist wanted to present him in a very casual manner. Working from the photograph on page 77, the artist developed an accurate and informative final sketch.

Here's an easy way to recheck your final drawing if you have any doubts about its accuracy. Place a clean piece of tracing paper over the face you have drawn, and trace the facial ovoid. Draw a center line and mark the features where you have placed them, using spheres for the eyes and a wedge shape for the nose. Then remove the tracing paper and look at what you have just drawn. Any mistake you've made will be easy to see on this simplified version of your drawing of the head. For instance, you may find in rechecking that the eyes are not located halfway down the facial ovoid. Whatever the problem, it's easier to correct once you know where to look.

The first concern is to decide on the size of the head and then to draw an ovoid accordingly. The next step is to locate the features. It's easier to establish the location of these guidelines by marking their approximate position to the side. You can see the marks next to the head above.

Using a clean piece of tracing paper the artist spots in the nose, eyeballs and hairline. The location of Jon-Marc's features conforms to the norm, so there is very little adjustment to be made.

The artist studies the shape of Jon-Marc's eyes, and draws the lids "over" the eyeballs. Next some of the clothing is added.

The artist gets down to locating the shadows and adding all the detail. Here's the final sketch. The drawing is ready to be traced onto the watercolor paper.

Jon-Marc

DEMONSTRATION

This is where it all comes together. It's exciting to see the clean, taut sheet of watercolor paper with the drawing in place, just awaiting color. In the following demonstration, you will paint a portrait of Jon-Marc. Remember four things:

Step One

Blocking in Color

In this first step, use a mixture of Cadmium Red (or Windsor Red, which is slightly cooler) and New Gamboge to block in the basic flesh color. The value should be light. There's no black in either of these pigments, so you're assured of a clear bright color.

Load your brush with a good amount of this mixture and paint it over the entire face and neck. Then immediately wash out your brush in clean water and moisten the hair area. Now add a light value New Gamboge to suggest the hair in sunlight. Don't cover the entire wet area with pigment—just drop a small amount into the middle and let the water carry the color. If some of the yellow flows into the flesh color, don't worry. You want a soft edge at the forehead, and any error can be corrected later.

You may want to use some more New Gamboge, or perhaps Cadmium Orange, to suggest the color of Jon's shirt. This is a good time to do it, but stay away from the face and hair until they are thoroughly dry.

1. Adhere to the 40 percent rule when painting the shadow side. (Objects in sunlight are a full 40 percent darker on the shadow side than on the sunlit side.)
2. Add reflected light to the portrait wherever possible.
3. Never use complementary mixtures at their darkest values.
4. Use pure color and permit it to blend on the paper rather than on the palette.

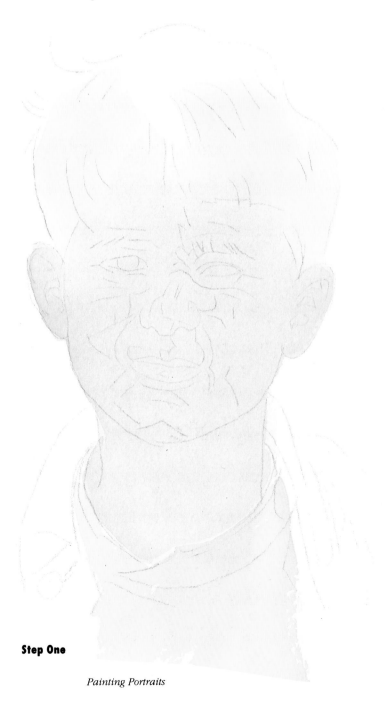

Step One

Jon-Marc

Step Two
Adding Shadows

Now for some excitement. You know where the shadows on the face are located from our careful final drawing. Look again to be sure you know exactly where the shadow edges are located, which edges you want to make hard and which ones should be soft. You may want to take your pencil and refresh your guidelines.

Mix two puddles of pigment: one of Sap Green and Raw Sienna, and another of Alizarin Crimson and Burnt Sienna. Use a scrap piece of watercolor paper to test the value of each of these mixtures. Remember, these colors must be dry when you evaluate them, and they must be 40 percent darker than the initial wash.

Have two brushes ready (use no. 5 or 6 round brushes), one for each of the mixtures. Start above the hairline with the green mixture and bring your brush boldly down into the area of Jon's right eye, across the nose and into his left eye. Immediately switch to the other brush and bring the warm color into the forehead and down the center of the cheek.

Now dip a clean brush into the New Gamboge. Be careful not to get the yellow too intense. Draw this color along the jawline and under the chin, letting it combine with the red mixture. Before this shadow side is dry, use the red mixture to paint the ear and the neck.

Survey what you've done. You probably have some dry hard edges that you wish were soft. That's okay. Here again, if necessary, you can make corrections later. The point is, you have been bold. Sometimes the watercolor pigments don't listen, but this looks fine.

To paint the shadow side, and the cast shadow on Jon's other cheek (*A*),

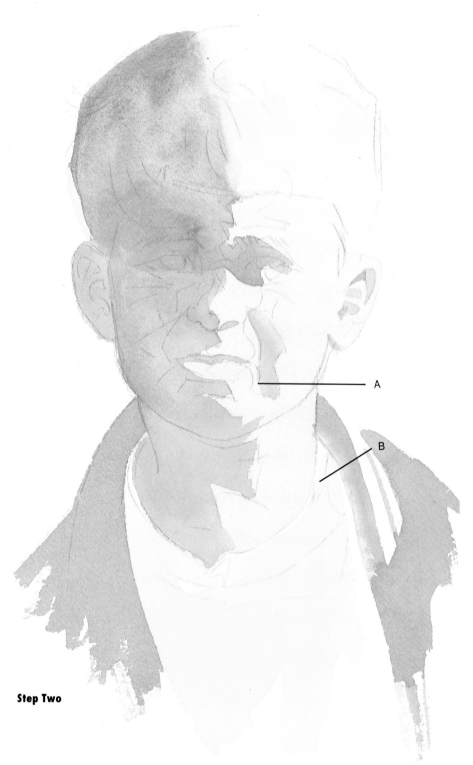

Step Two

use New Gamboge nearest the mouth, with Cadmium Red alongside. Soften the edge with a moist brush. Now put the darks into the ear.

To suggest reflected light on the jacket, use New Gamboge, then an intense Cadmium Red laid alongside (*B*), much the same as in the cheek.

Step Three
Modeling the "Sunny Side"

This part is really fun because now you're going to model the face in sunshine. Of course, it's impossible to model only a part of the face at one time—you're going to want to carry a brushstroke into the shadow side—but at least you can start on the sunny side.

Consider the parts of the face that are turned slightly away from the direct light. These areas will be cooler than the sunny side, so you must paint them that way, even if this coolness isn't very apparent in the photograph.

After washing the palette (which has become a real mess) and filling the container with clean water, use a light- to middle-value mixture of Alizarin Crimson and Burnt Sienna to model and cool facial areas. Try to let your brush follow the facial contours (A). You may want to begin with a brush loaded with pigment, then add water as the stroke advances. Notice the cast shadow on Jon-Marc's left cheek at this time (B). Now you can paint more color into the hair, remembering that the color must become cooler as it approaches the shadow side.

There are still some edges that you might not like, but continue. If you make all the corrections at the last, you won't have any damaged paper to contend with during the painting process.

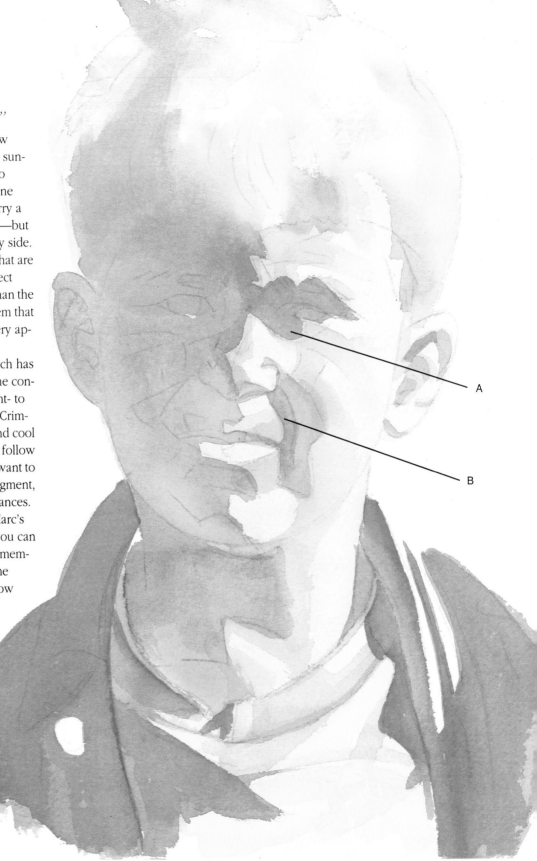

A

B

Step Three

Jon-Marc

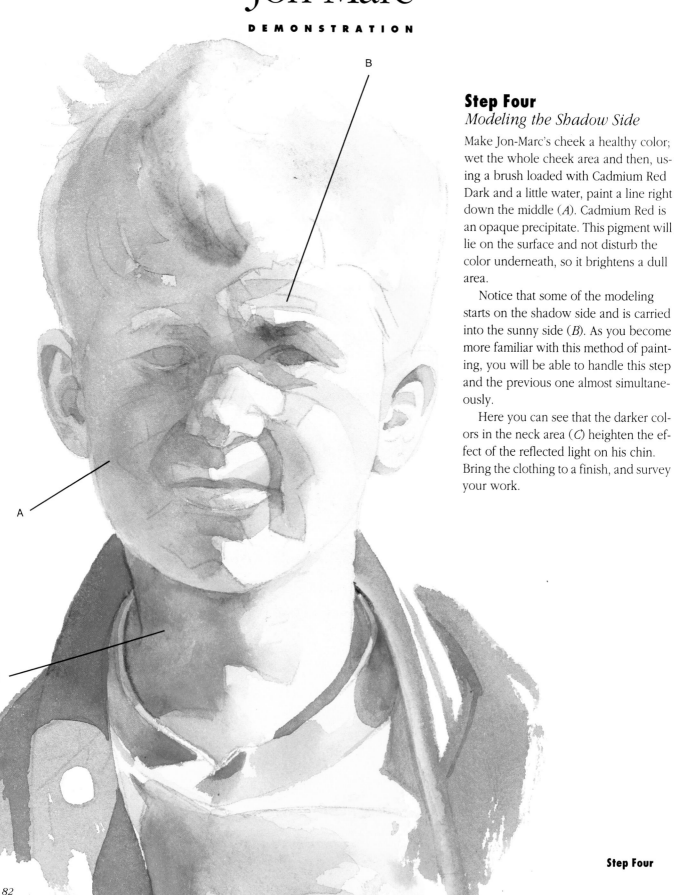

Step Four
Modeling the Shadow Side

Make Jon-Marc's cheek a healthy color; wet the whole cheek area and then, using a brush loaded with Cadmium Red Dark and a little water, paint a line right down the middle (*A*). Cadmium Red is an opaque precipitate. This pigment will lie on the surface and not disturb the color underneath, so it brightens a dull area.

Notice that some of the modeling starts on the shadow side and is carried into the sunny side (*B*). As you become more familiar with this method of painting, you will be able to handle this step and the previous one almost simultaneously.

Here you can see that the darker colors in the neck area (*C*) heighten the effect of the reflected light on his chin. Bring the clothing to a finish, and survey your work.

Step Four

Step Five
Adding Darks and Details

Finish the eyes and eyebrows. Slightly moisten the eyebrow area with clear water. Then get a rather thick blob of Raw Sienna on the tip of a small brush. Deliberately daub the brush tip where you want the brow to appear darkest. You may want to add other colors as you draw out the brushstroke along the brow line, the choice is yours.

Next add the eyeballs. Use a dark purple combination of Alizarin Crimson and Winsor Blue, and then complete the eyes with a touch of pure Alizarin at the corners.

Now for the corrections. Use a slightly moistened, stiff bristle brush, like the brushes oil painters use, to soften any edges that may look too hard.

One final tip: If for any reason you're not happy with your painting, try painting over the entire face (once it's dry) with clear water. This tends to soften all the edges and unify the head. If this doesn't work to your satisfaction, try mixing a very light-value puddle of Cobalt Blue with a touch of Alizarin Crimson. Be sure this is a clean mixture with no other pigments added. Then paint this mixture over the entire shadow side, using light brushstrokes so as not to disturb the pigment beneath. This will serve to subdue too severe contrasts and further unify the shadow side.

Young African-American

With darker complexions, you might use pigments with some black content, but they can be combined with pigments that contain no black to enhance their brilliance. Try Cadmium Red mixed with Raw Sienna or Yellow Ochre for dark complexions. Another choice might be Burnt Sienna with Alizarin Crimson.

Studying this face, it's apparent that the artist could logically include blue reflected light on the shadow side along the subject's cheek. There is no light actually bouncing off of his blue-black sweater. However, because it *could* be there, the artist can force a color accent and still not disturb the viewer's eye. On the contrary, such color would add interest and brilliance to the painting. The shadow pattern on the subject's face is relatively simple, so this would make a good practice portrait.

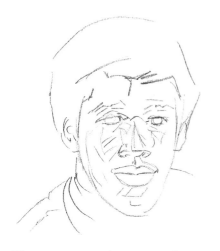
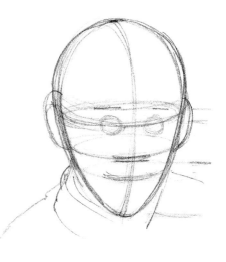
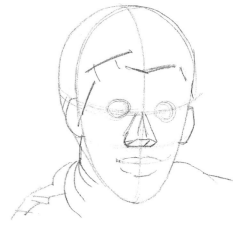

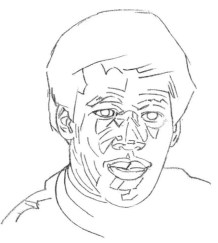
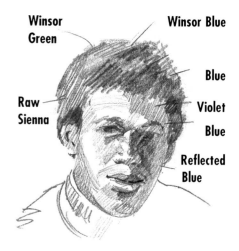

Winsor Green

Winsor Blue

Blue

Raw Sienna

Violet

Blue

Reflected Blue

These preparatory drawings are based on the photo using tracing paper overlays. The artist also jotted down color notes on the original pencil sketch (bottom right).

Step One
Painting the Skin

After the final drawing is transferred to the watercolor paper, paint the skin color a warm mixture of Cadmium Red and Raw Sienna.

Step Two
Painting the Shadow

It's time to paint the shadow side when the first wash is dry. Don't worry that the value of the shadow side appears too dark.

The first shadow mixture is Ultramarine Blue and Alizarin Crimson. Begin with the subject's forehead and paint down to the bridge of his nose Then, before the paint can dry, use a brush moistened in clear water to soften the edge over the eye. Next (here comes that reflected light), dip into Winsor Blue and permit that color to combine with the violet at the subject's temple. The rest of the shadow side is completed using these colors.

Now wet the hair area and drop in pure color—Raw Sienna to suggest sunlight, then a cooler Winsor Green, and finally Winsor Blue into the shadow side. Some of this blue floods down into the shadow side of the face.

Step One

Step Two

Young African-American

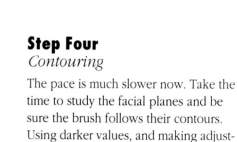

Step Four
Contouring

The pace is much slower now. Take the time to study the facial planes and be sure the brush follows their contours. Using darker values, and making adjustments along the way, you can see the young man's face take shape.

Step Three
Painting the "Sunny Side"

Modeling the sunny side is next. Notice the cool color on the jawline just under the right ear. Paint this area with a light violet to suggest the subject's beard. The modeling on his cheek and on the top of his nose is accomplished with a mixture of Alizarin Crimson and Burnt Sienna. These colors accent the portions of his face that are turned slightly away from direct light and are therefore somewhat cooler than the side of his nose and cheek.

Step Five
Finishing

Look at the subject's right eyebrow. The portion nearest the right temple is lighter and perhaps bluer than directly above the eye. The left brow also appears to have some reflected light in the temple area. To paint the brow line, dampen the area with clear water and daub pure Winsor Blue into the darkest portion. Before this can dry, add Burnt Sienna over the Winsor Blue to add color and warmth.

Finish the portrait using various combinations of the colors used throughout the painting.

After the painting is complete, erase the pencil lines and make any corrections, such as softening edges or lifting highlights.

A Mother and Baby

Baby Hannah was just one week old when the artist met her and took a few pictures. How do you do a portrait of a one-week-old person? She is so small and she is lying down or being held all the time. But the artist was captivated by her miniature perfection—such tiny hands and delicate features.

It seemed best to paint Hannah with her mother, but the artist didn't want a painting of a full-sized lady with a postage stamp of a child. So she decided on this double figure close-up to bring Baby Hannah into the foreground and capture her newborn glow. The artist conveyed Abby's love for her child by concentrating on her expression and supporting hand.

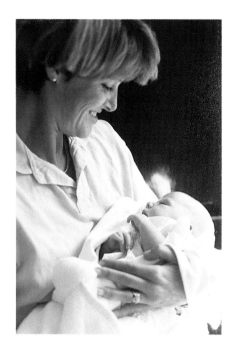

Step One

Establishing a Wash

The drawing was rendered on heavy tracing paper with a pen, then lightly traced onto 140-lb. Arches watercolor paper with a no. 2 pencil.

Starting the painting process in a loose way, the artist applied the first watercolor wash of Yellow Ochre and Scarlet Lake over Abby's face with a no. 12 brush, purposely ignoring the outlines of the head. While this first wash was still wet, the artist dropped in Cerulean Blue at the top of the head and more Scarlet Lake on the cheek area, then Permanent Rose over the upper part of the shirt, letting the colors flow down and blend. (The artist works upright on an easel, even with watercolors. The flow of colors, one into another, gives beautiful transparent color that cannot easily be achieved when working flat on a table.)

Step One

Step Two

Adding "Shine"

More Permanent Rose was added to the shirt, leaving some white, irregular shapes at the lower edge where the shirt meets the baby's blanket. Working with great care, the artist laid the Yellow Ochre/Scarlet Lake wash over the baby's head, leaving a soft edge at the crown. Some orange was added in an attempt to get that "candle glow" that babies have. The color was concentrated at the face. Even though it was a very small area, the artist wanted Baby Hannah's head to be like a shining jewel in this painting.

When the face was dry, the artist added a light Cerulean Blue over the nearly translucent eyelids and to the area between the baby's tiny nose and upper lip. This blue was used to "turn" the plane of the face away and to delineate

Step Two

the form of the head at the side and back of the cranium.

Then the focus went to Abby's hand. To keep the hand darker and less bright,

the artist stepped down from Yellow Ochre to Raw Sienna and kept the color particularly warm in the lower part of the hand where it was receiving so much reflected light.

Step Three
Adding Skin Tones

Trying to keep the color transparent and luminous, the artist laid in the palest flesh-colored wash on the baby's hands and arms.

Abby's hair needed some Raw Umber definition. When the color started to look too hot, it was cooled down with Cerulean or Cobalt Blue washes. These colors also were used to define the back of her neck.

The artist began to define Abby's eye and nose with warm and cool layers, at the same time beginning to pull out the shape of the face from the first wash. Remember: *All the openings in the head* (the eyes, ears, nostrils and mouth) *are warm* and should be painted with warm colors: golds, oranges, reds, warm purples. Warm colors give the head a feeling of life. The artist lifted the shape of Abby's teeth with a barely damp sponge and a stencil cut to that shape.

The painting needed some definition in the baby's blanket and dress, but the artist didn't attempt to copy all the intricate folds. Pale washes of Cerulean Blue, Cobalt Blue, Scarlet Lake, Permanent Rose and Yellow Ochre were put on, one color at a time. In places where the paint was wet, they intermingled.

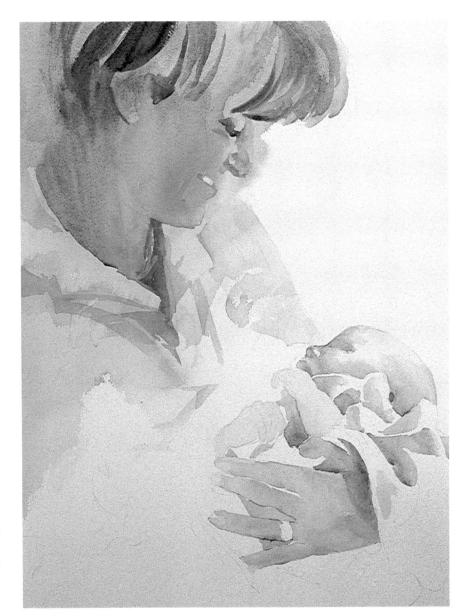

Step Three

A Mother and Baby

Step Four
Defining the Figures

The artist laid in the dark background with Cobalt Blue and Ultramarine Blue, dropping some warms—Raw Umber, Alizarin Crimson—into it while wet. She painted warms and cools on the mother's hair, neck and face, then pulled darks over the hair, neck and collar areas and in the eye.

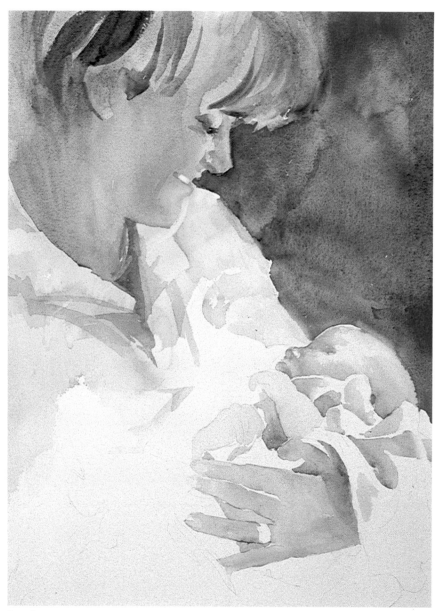

Step Four

Step Five
Adding Washes

The front of the shirt was laid in at last, defining the blanket edge. The artist let whites leak in and out because she didn't want any hard line between the mother and the infant that might suggest a barrier. Next she laid in a deeper, warmer fleshtone (Yellow Ochre and Scarlet Lake) in the shadow area of Baby Hannah's left forearm and hand. While this was still damp, the artist put in the palest blue halftone between the shadow and the light to give form to the little arm.

A few more pale washes were laid on the blanket toward the lower left corner to subdue that area, along with deeper color added to Abby's shirt there.

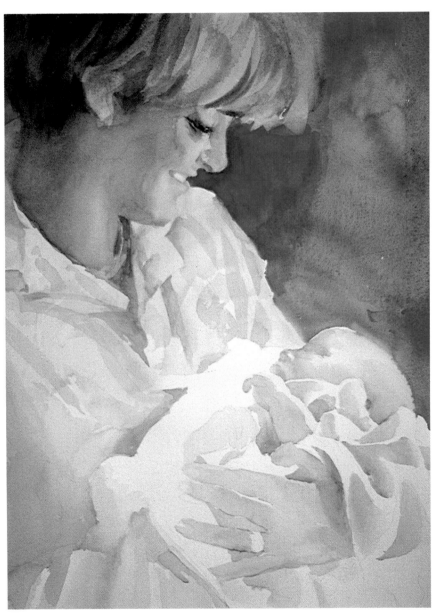

Step Five

A Mother and Baby

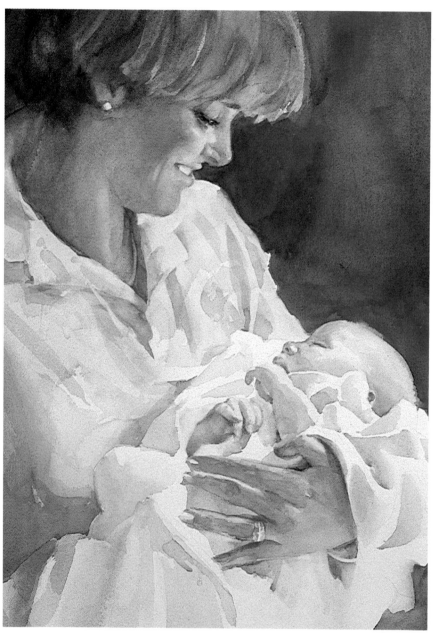

Step Six

Step Six
Adding Definition and Warmth

The artist worked at finishing Abby's hand—always holding back, not defining too much—adding warms, cools, preserving the lights on the thumb, the fingernails, the ring and the second finger. She added more definition to Baby Hannah's features and right hand, trying hard to make the little finger project and yet not have more emphasis than the mother's hand. A small dark was added at the lower right corner to make the blanket edge as interesting as possible without becoming a distraction.

Next, the blues in Abby's neck were warmed. The artist began to feel Abby's portrait was becoming too young and glamorous, so she restated the laugh line just left of the mouth and lifted out the pearl earring.

To deepen the background the artist added more dark washes so the figures would shine.

The Finish
Lifting Highlights and Adding Accents

Finally the artist checked all over the painting to lift out highlights and add accents. The background was blotchy and unattractive, so the artist decided to have fun with it and do something different. She used a stencil precut for wall decoration to paint darks over the blues, turning it frequently so the design would not look too mechanical. Now the uneven blue in the background became an advantage. This large area had interest but still dropped away from the figures, allowing mother and child to shine.

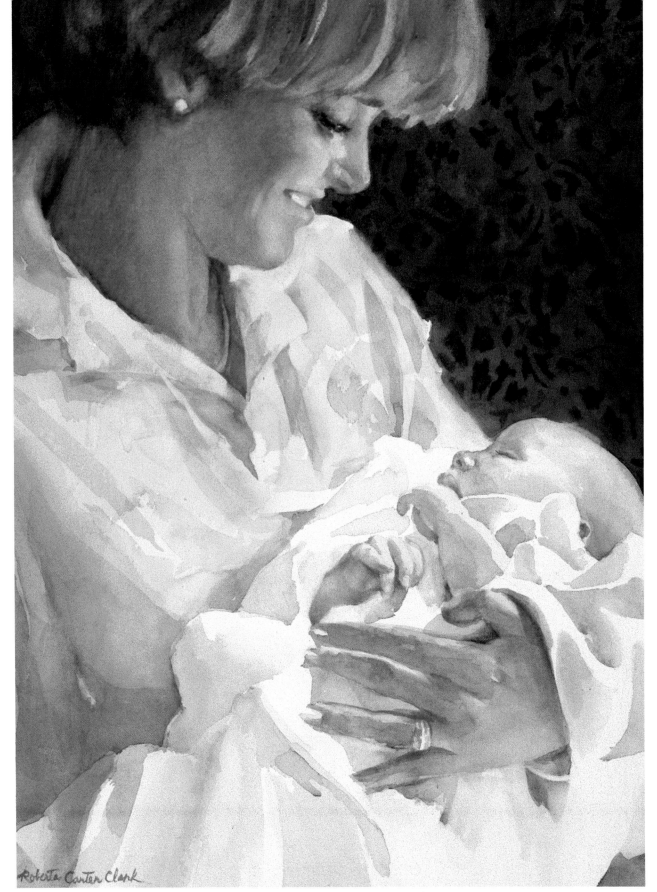

Finish

Abby and Baby Hannah, 20" × 15"
Roberta Carter Clark

Painting Children
Age and Proportion

When painting children, age and size are vitally important. Children are constantly changing as they grow older, and you don't want to paint a three-year-old and have him come out looking as if he were six. The secret is *proportion*—proportion of the head to the entire body, to the torso, to the arms and legs. The way to work with proportion is to think of the child's body in head lengths.

In the chart below, you will see children from babyhood to the teen years.

As you study them, you will understand the concept of measuring a figure in head lengths. The baby has a very large head for his body; it is one-fourth his total height. We say the standing baby is "four heads tall," which is a misnomer because the baby doesn't "stand" at all.

This relationship between head length and total body length changes with each year of the young person's growth. Note that all of these figures are standing with their weight equally distributed on both feet. If a child is stand-

ing with more weight on one foot, or if he is seated, the proportions change because the balance changes.

The halfway mark is also important and is shown on these figures by the horizontal orange line. Many times it helps you to draw the figure if you know where the midpoint should be. This keeps you from getting the torso too long and the legs too short—a common error. From the age of six on, the midpoint is almost always at the hipline.

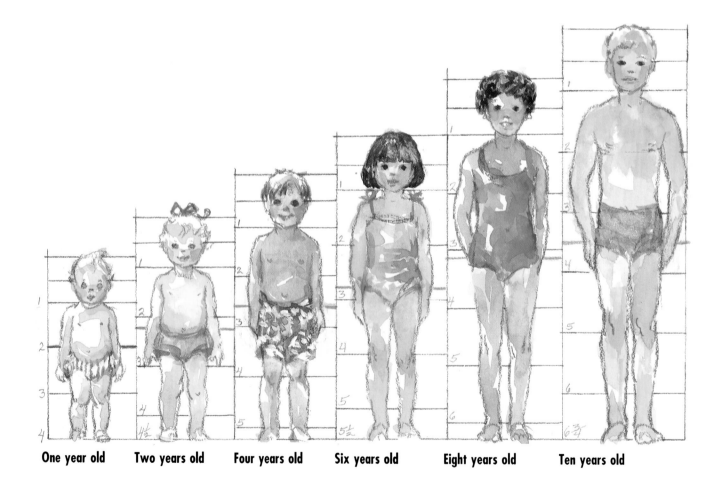

One year old **Two years old** **Four years old** **Six years old** **Eight years old** **Ten years old**

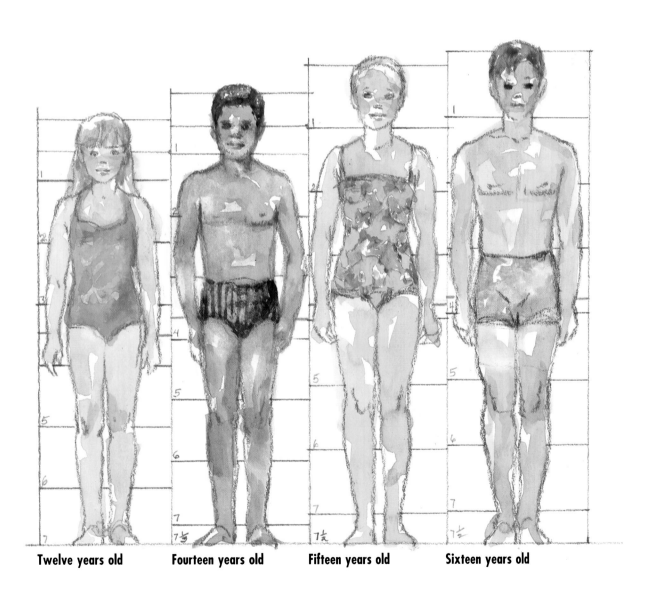

Twelve years old　　**Fourteen years old**　　**Fifteen years old**　　**Sixteen years old**

Shape and Structure

There are no straight lines anywhere on the healthy child's body, only curved lines and soft contours, at least until the young one is five or six. Babies are roundest of all, for their bodies have more fatty tissue and their muscles are not yet developed. This does not mean that you can draw them as nothing more than fleshy blobs, shapeless and puffy. Both in the torso and the limbs there is a discernible rhythm of curves, one offsetting another.

As the child grows the fat diminishes, the limbs become longer and much more slender, and these curves become ever more subtle. If you look at the arms and wrists of children of all ages you can't help but notice how delicate and graceful they are. Careful observation is necessary if you are to draw them well.

It helps to draw the body first as if the child were in a swimsuit or underwear. Large sweaters, puffy sleeves and full skirts camouflage the body. It's always better to draw the body first and then put the clothes on it than to paint the pants or dress and hang the legs and feet from the hem. Clarifying the position of the knees beneath the clothing gives the figure a more believable structure.

The Torso

Young boys and girls have very similar torsos, sometimes with quite round tummies. Girls do not usually develop a waistline until they are about six or seven. Because of this, dresses with high waistlines are flattering to little girls younger than this. Boys don't have a waistline any more than grown men do; their pants sit low on the hips. For this reason, young boys and girls often have straps holding up their pants or skirts until they are five or six years of age.

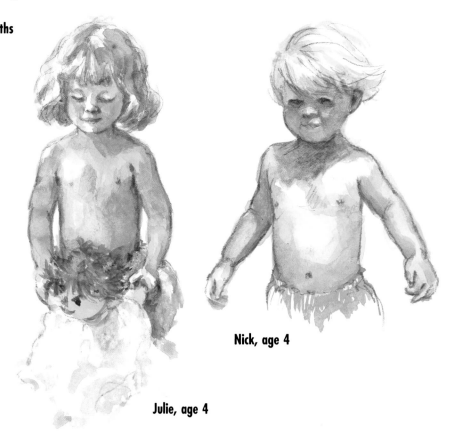

Ray, age 7 months

Nick, age 4

Julie, age 4

Curved Arms *A drawing by Francois Boucher, 1703-1770. Notice the curved outlines on the arms; they are not just lumps, but rhythmic ins and outs conveying solid forms very well.*

Hands

At birth, a baby's hands seem fragile and exquisite; we are amazed at their miniature perfection. By the time the child is two, the hands have taken on a pudgy quality with soft and rounded contours. The fingers do not look segmented yet, and there may be dimples on the back of the hand at the knuckles. During these early years, the fingers seem to bend and move almost independently of each other, almost as if each group of four fingers and a thumb were not yet a complete set. After age three, the fingers are less rubbery looking, and you can begin to define them in segments.

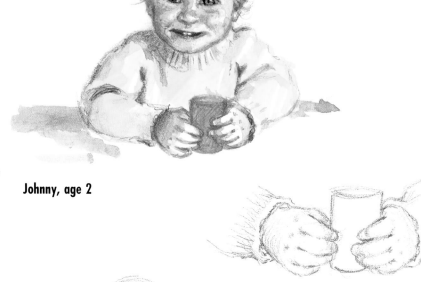

Johnny, age 2

Drawing Fingers *Even though the fingers of very young children don't appear segmented, you will have more success if you first block in the individual segments to help you achieve the correct length and proportion of the fingers relative to each other and to the hand itself.*

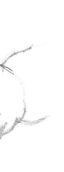

Often babies' fingers will each seem to go their own way.

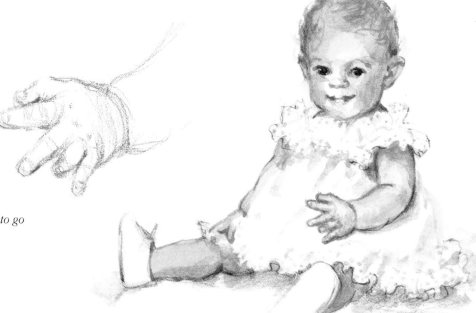

Nancy, age 11 months

Hands

Gradually, as the child matures, the hands grow longer. Some become slender and graceful, but some are still square and blocky. Draw the fingertips rounded or squared, but not pointed, and with short, shiny fingernails. Fingernails help the painter define the top side of the finger, which is especially nice when you want all the fingers on one hand to move together in a gesture. And they let you paint a small highlight on each nail, which becomes like a wee bit of jewelry.

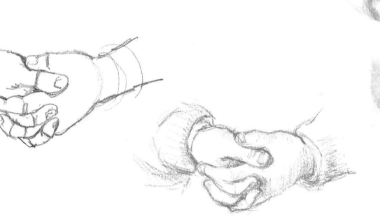

Kyle, age 7

Older Hands *As children get older their fingers are more clearly segmented and their hands develop grace and character. The wrists lose their baby fat.*

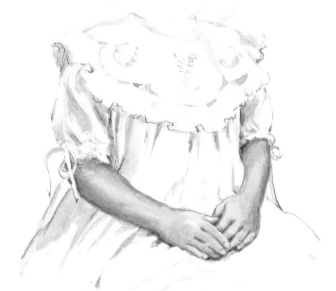

Aurie's hands, age 5

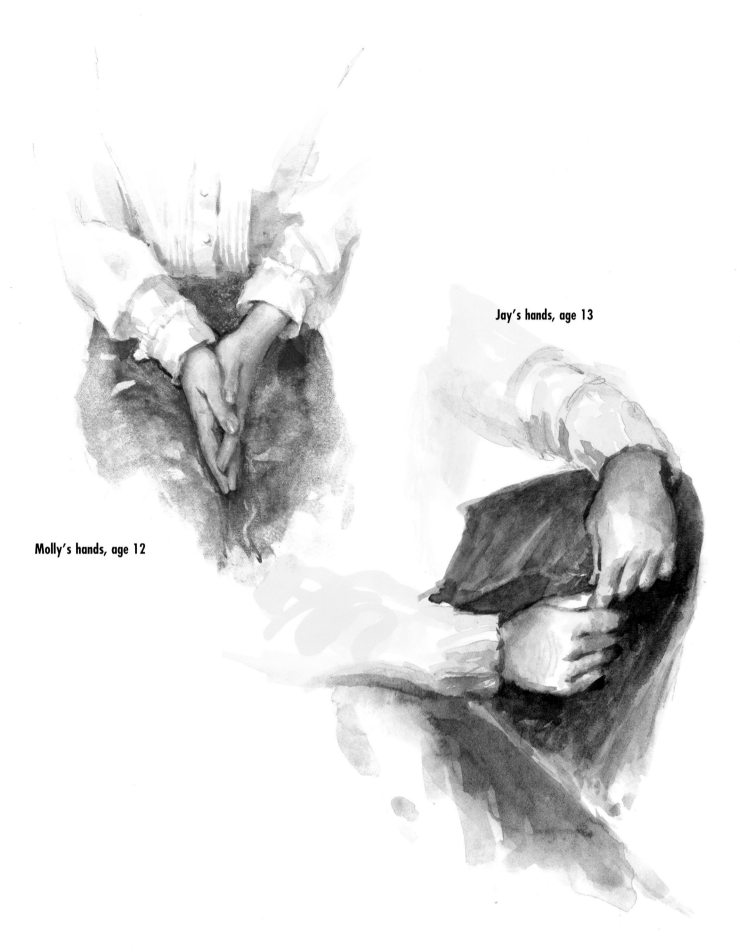

Jay's hands, age 13

Molly's hands, age 12

Legs and Feet

When painting children, you will have many opportunities to paint their legs and feet. These little legs and feet are delightful to see and they add so much charm to a portrait.

The legs and feet of babies and toddlers are rounded and chubby, with small round toes. Even the soles of an infant's feet are rounded until he starts wearing shoes and standing upright. Baby fat surrounds the knees and ankles. The legs are short and stubby relative to the body.

To draw the foot, think of it as a wedge shape that flattens out at the toes. When the child is standing, the outside of the foot from the little toe to the heel is flat to the ground. The main arch of the foot is on the inside. In children, this arch is only barely visible. However, when drawing or painting children's feet, try to emphasize a difference between the outside and the inside of the foot to distinguish the right foot from the left.

Notice that the big toe is often separated from the other four toes, rather like the way the thumb is separated from the fingers.

When drawing the foot, you may do better by blocking it in with straight lines. The feet should look strong enough to support the body. In an adult, the foot is one head-length long, but this certainly is not true of small children. You'll have to study the youngster's feet extra carefully to get them the correct size for her body. Feet are not easy to draw. Putting the small toenails in helps to indicate the direction of each toe and thereby helps with the perspective of the foot. If you just can't get the feet right, put little sandals or shoes on them. You may find this easier (but not much).

As the child gets older, the legs and

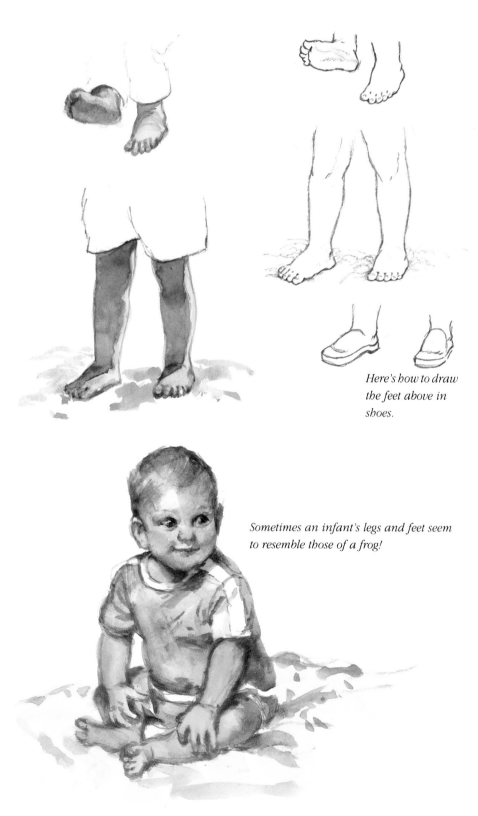

Here's how to draw the feet above in shoes.

Sometimes an infant's legs and feet seem to resemble those of a frog!

feet, like the arms and hands, become longer, more slender and take on more muscle definition. Many children's legs become very slender, giving them a colt-ish look.

It's fun to paint a child all dressed up and then leave the feet bare. This keeps the portrait from becoming overly formal and reminds us that the child is not a miniature adult, but rather an unfinished one.

When you're ready to put paint to paper, remember: All the extremities of the body are *warm*. This means that the fingers and toes, ears and nose, are warmer in color than the rest of the flesh—more pink, rose or coral.

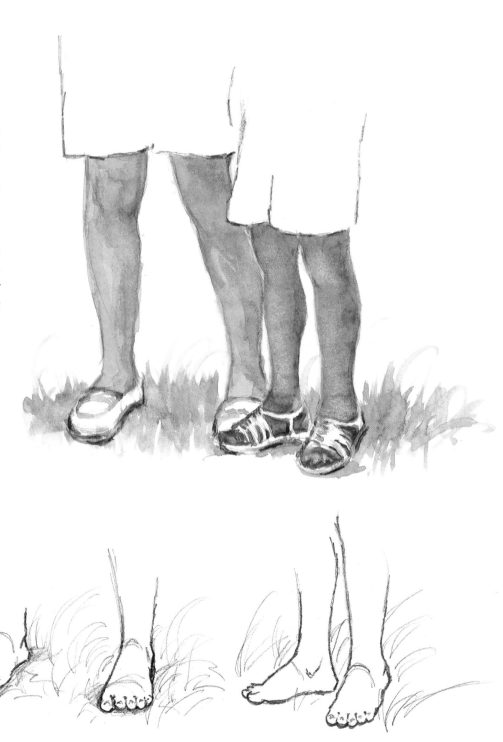

Girl With Baby

DEMONSTRATION

In a reflective painting, the mood should be gentle, the colors warm and intimate, and the edges soft and round. The following five steps will help you create an intimate portrait.

Step One
Creating a Wash

1. After transferring the drawing, the first step is underpainting the skin tones on the hands and faces of both children with a light wash of New Gamboge and Alizarin Crimson. The folds in the blanket can be handled one at a time. First, moisten the area, paint a line of Ultramarine Blue at the top of the rounded fold, then immediately add a warmer color as the fold curves away from the light. Wash your brush out after each additional color. No hard edges here—they can be added later after all is dry.

2. If you don't get it right the first time, don't be discouraged. Getting the correct ration of water to pigment takes practice.

Step One

Step Two
Adding Shadows

1. Add the shadow side to the faces using a rosy mixture of Alizarin Crimson and Burnt Sienna.

2. Continue to develop the folds in the blanket and along the baby's arm. Add yellow to suggest reflected light while the blue pigment is still wet. When you work wet-into-wet, the colors may move where you don't want them to go, but don't be tempted to correct them. In the final painting you may like them exactly where they are, and you can ruin a painting by working back into an area that has already started to dry. The time to make corrections is after everything is thoroughly dry and you have a chance to analyze the problem.

Step Two

Girl With Baby

DEMONSTRATION

Step Three
Adding Values

1. Begin to model the rounded curves in the children's faces using darker mixtures of Alizarin Crimson and Burnt Sienna. When this color appears too hot, switch to a warm violet. The cast shadows have hard edges. Begin next to the baby's hand and use a dark value Ultra- marine Blue plus Alizarin Crimson to suggest the cast shadow. Draw that color out with clear water and continue up the blanket and across the little girl's face. Repeat this process where the shadow falls across the baby's hand. Go slowly and pay attention to the dark and light places within the shadows themselves. Be careful not to get so much water on your brush that you lose control, or so little water that the brushstrokes are visible and jagged.

2. Add the darks around the fingers and use Alizarin Crimson and Burnt Umber to tuck the baby's head down into the blanket. Use a cool Blue Violet to model around the eyes of both children.

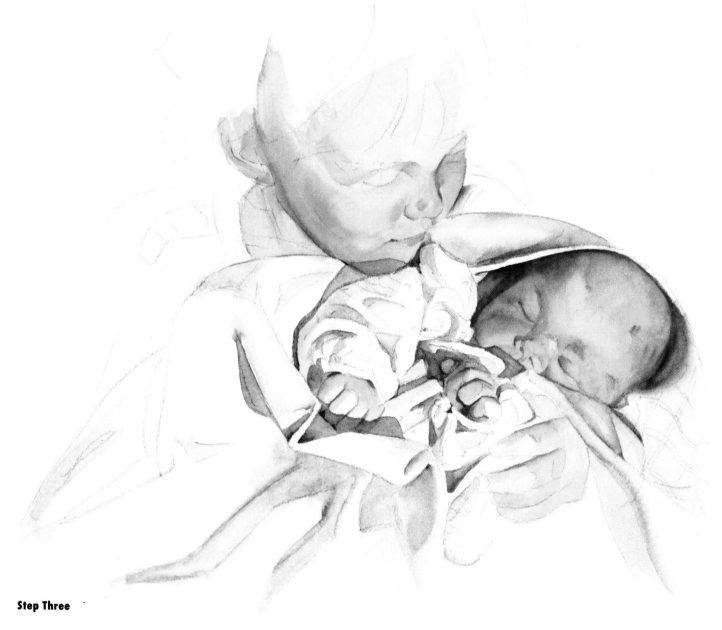

Step Three

Basic People Painting Techniques in Watercolor

Step Four
Adding Details

1. When painting hair, the trick is to wet the area first, put pure color into your brush, and paint one brushstroke at a time following the contours of the head. Let the colors touch and mingle on the paper. Don't go back, and don't mix color in the palette. Remember, most of the water you need is already on the paper. The colors used here are Burnt Sienna, Raw Sienna, Alizarin Crimson and Ultramarine Blue.

2. The eyebrows and eyelashes are treated much the same way as the hair only with less water. Dampen the place where you want them to appear, then touch your color to the place that appears darkest. Let the water carry the brow or lash softly the rest of the way. If you need more water, gently pull the color across with a clean dampened brush.

3. Finally, use New Gamboge and blue to do the stripes on the blanket, carefully following the contours.

4. Underpaint a background color now. The artist of this painting used a light Blue Violet to define the edges of the blanket and then painted that color into the edges of the hair on the older child.

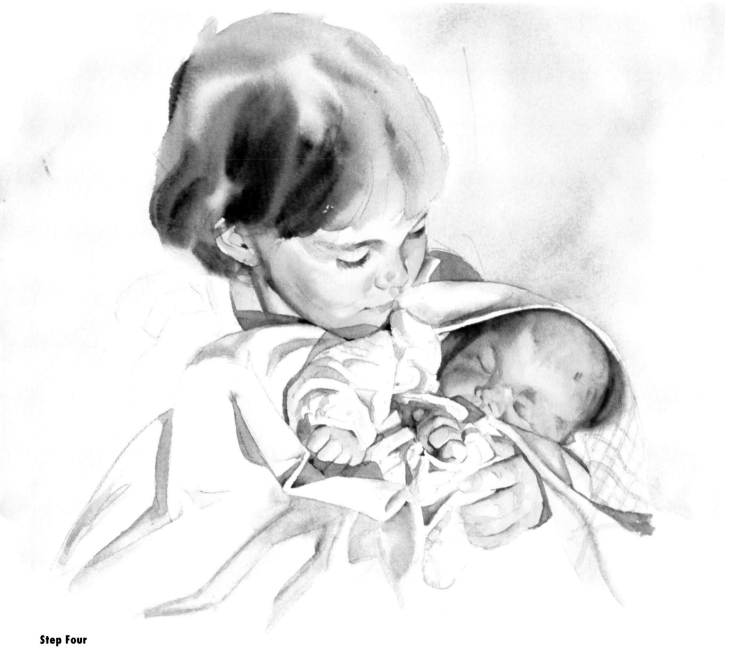

Step Four

Girl With Baby

DEMONSTRATION

Step Five
Making Changes and Adding the Background

Now assess your painting and make any adjustments necessary. Do you need to soften an edge or warm a recessed area?

To enhance the feeling of intimacy, the background should seem to surround and caress the figures.

Girl With Baby, Jan Kunz

Step Five

Basic People Painting Techniques in Watercolor

Running Toddler

DEMONSTRATION

To paint a lifelike portrait of a toddler is to paint motion. Because movement is so much a part of the character of these little ones, many artists like to include the whole body in the portrait. When you make a drawing from your own photograph of a baby or toddler, be sure you look carefully at the proportions. The head is much bigger relative to the body than an adult head.

Step One
Washes of Color

Because this child is a little redhead, you want to keep the fleshtones warm so she doesn't look ill. Instead of using Alizarin Crimson, a cool red, as one of the basic colors in the fleshtone mixtures, use Winsor or Cadmium Red and New Gamboge.

1. First, wash in a light wash of Winsor Red and New Gamboge and paint all the skin. Extend the color well beyond the hairline so the hair will not look pasted on later. Paint right over the lips and other details. Let it dry.

2. Paint the dress. Since it is a white dress, paint the shadows, leaving the white of the paper for the fabric in sunlight. Since reflected light can be any color, you will be using a number of colors in the shadows to show reflected light. This will also keep the shadow color from being flat from one side to the other, which is boring.

Remember that cast shadows, such as the shadow cast by the child's chin, are going to be slightly darker than the rest of the shadows. Begin with a mid-value wash of Cobalt Blue as a basic shadow color and add Rose Madder, New Gamboge and Ultramarine Blue to enliven the color as you work across the dress. Watch the edges carefully because they suggest folds in the cloth. Let it dry.

Step One

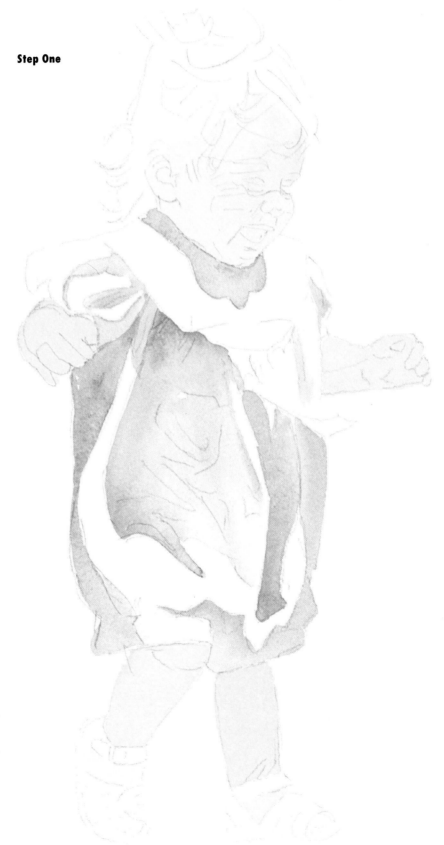

Running Toddler

Step Two
Shadows

1. On the shadow side of the face, wash in the dark shapes around the eyes and forehead, keeping the shapes large and simple. Mix a warm violet from Winsor Blue and Rose Madder for the shadow across the forehead and down into both eyes. Add a little more blue into your shadow color at the bottom and add more warm color as you work upward.

2. Use New Gamboge along the jawline and flood in a mixture of Burnt Sienna and Alizarin Crimson working up into the nose, across the cheeks and into the hairline. The trick is to use enough water on your painting so it remains wet enough for you to complete an area, yet allows you to go on to the next area of color and value without a hard line forming.

3. Do the basic hair color because it is still very light in value. Make it very colorful. The artist used Cadmium Orange as the base color and added New Gamboge for the reflected lights and Burnt Sienna floated into it. Make a shadow color of Cobalt and Alizarin, and float the color into the still-wet hair, letting the colors mix on the paper. Keep the edges soft.

4. Paint the arms, hands and eyes the same way.

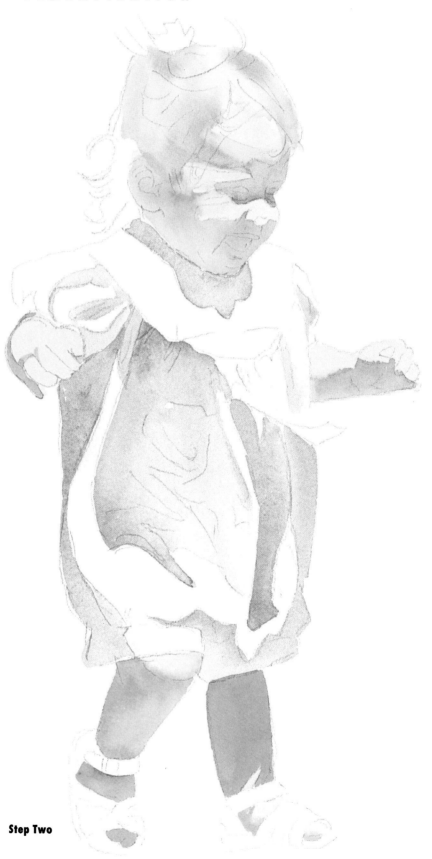

Step Two

Step Three
Details

1. Rewet the hair so the edges will remain soft. Use Alizarin Crimson and Burnt Sienna to work around the head to build up the shadow on the head. Paint the shadow under the ear by adding some Burnt Umber and Alizarin. Pull some of the color into the neck and darken under the chin.

2. It is important to make your brush go in the direction of the object you're painting and to make your brushwork confident—a confident stroke looks better even if it is wrong.

3. Paint the nose, making the base yellow with Alizarin Crimson at the top. Use Burnt Sienna and Alizarin Crimson for the dark of the mouth and details in the ear, underneath the eyes and to define the edge of the nose. Remember, warm colors are used for any place where light can't get.

4. Let it dry. Now flood some water over the cheeks and add Cadmium Red into the center. Move the pigment about with the tip of an almost dry brush into position to describe the child's rosy cheeks.

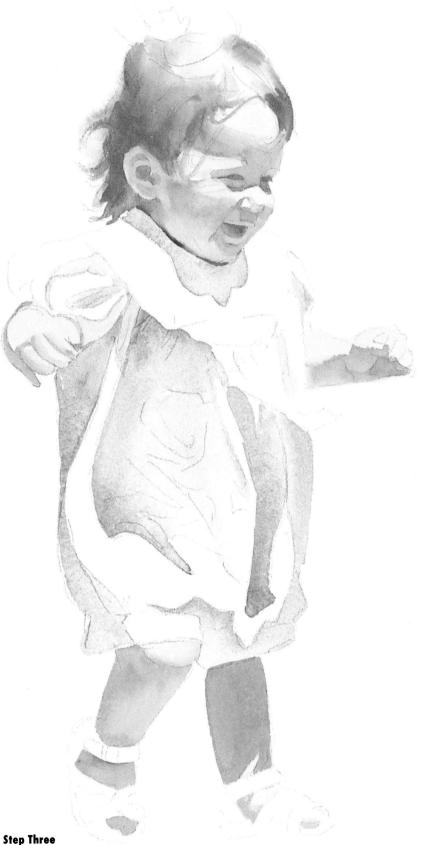

Step Three

Running Toddler

D E M O N S T R A T I O N

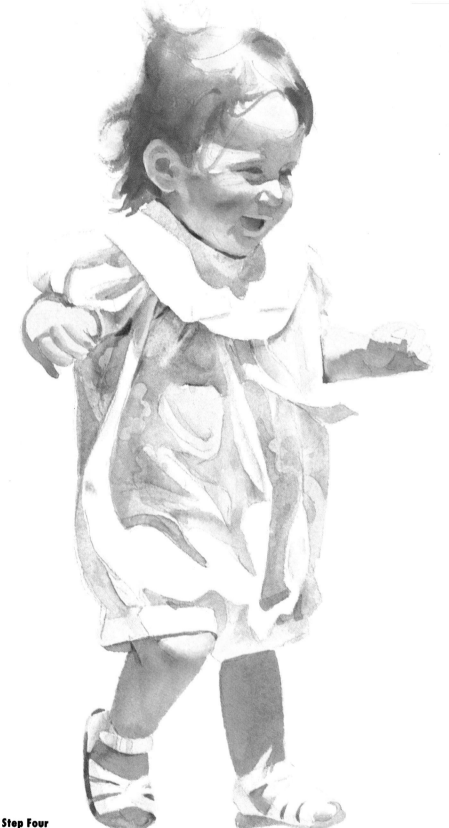

Step Four

Step Four
Darks, Layers and Shadows

1. Darks are built up in layers. Paint the darks in the dress and model them with warm and cool variations of Cobalt Blue and Alizarin Crimson. Paint the bow on her collar and the shadow beneath it.

2. Make the ribbon look as if it is curling up by using Rose Madder and New Gamboge to darken it right on the edges and adding reflected light where it starts to turn. Leave a white keyline on the edge and drop in color for the reflected light.

3. Paint the shadow side of the child's shoes with a mixture of Burnt Sienna and Ultramarine. The sole of the shoe is Burnt Umber and Alizarin Crimson.

4. Add the crevice darks to define the edge of the cuff on her bloomers.

Step Five
Reflected Light and Background Color

Add some yellow in the eyebrows for reflected light. Use a Cobalt Blue wash around the edge of the collar to define it more clearly. As a final touch, add the background color using a complementary gray-green made of Sap Green and Burnt Sienna. Add the warm dark on the bottom while it is still wet, but keep the edges soft so it won't be too abrupt.

Basic People Painting Techniques in Watercolor

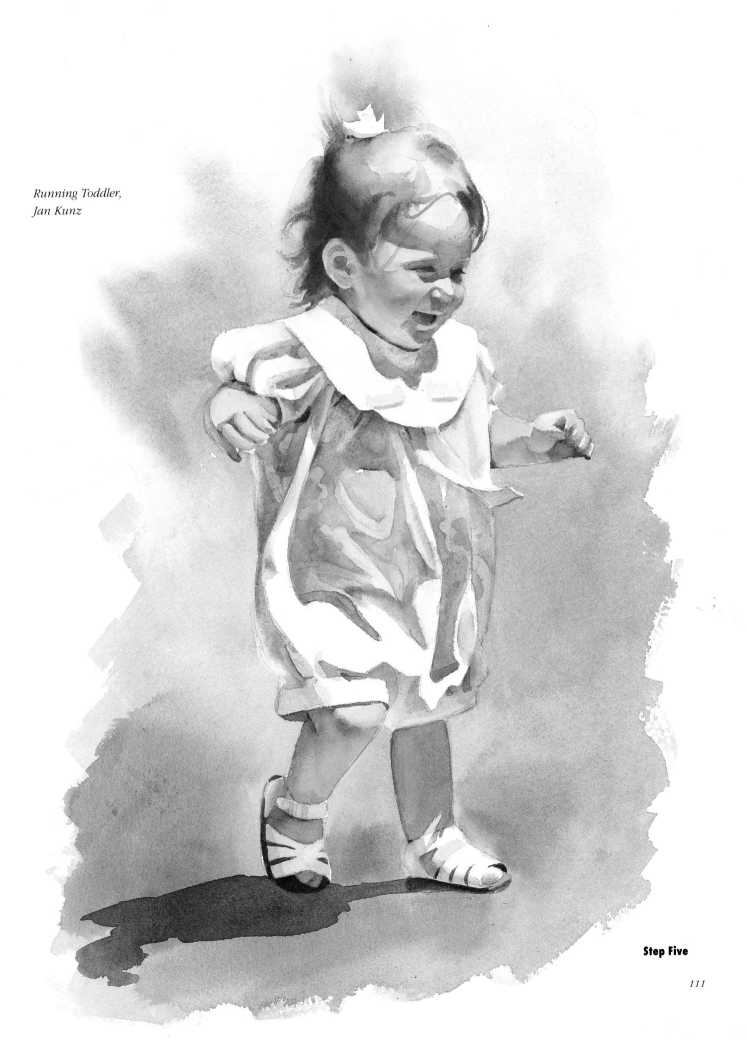

Running Toddler,
Jan Kunz

Step Five

Julie and Her Dolls

DEMONSTRATION

This watercolor was painted from a photograph the artist took some time ago of Julie in preparation for a pastel portrait. Julie was four at the time. It is transparent watercolor on 140-lb. Arches paper.

Step One
Laying Down Color

The first step was the pencil drawing done on heavy tracing paper. After tracing the drawing onto the watercolor paper, the artist started the painting process. She wanted the viewer to be able to differentiate between the skin tones of Julie and each of her dolls. The doll on the left, which had orange hair, was painted with a mix of Alizarin Crimson and Yellow Ochre. The baby doll on the right was painted with a very pale mix of these same colors, but less pinkish. Julie's skin tones required a warm glow, so the artist used a mix of Yellow Ochre and Scarlet Lake, occasionally cooled with Cerulean Blue. She painted at least three washes on her flesh areas, allowing each one to dry before applying the next.

The baby doll's dress was painted with Cobalt Blue and her high chair with Raw Sienna and Raw Umber. New Gamboge was used for the yellow cushion on the chair in the background.

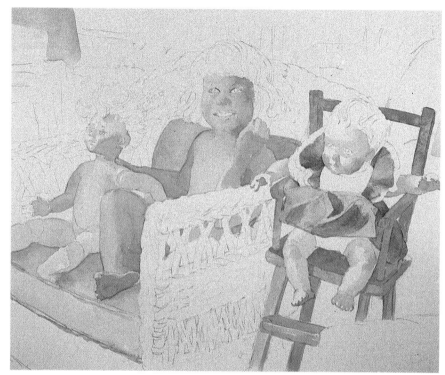

Step One

Step Two
Adding Washes

The grays in the wicker chair were painted with Cerulean Blue and Burnt Umber. The orange hair came next, then Julie's hair, made with Yellow Ochre, Raw Sienna and Cerulean Blue laid on one color at a time. The lightest lights in Julie's hair are the white of untouched paper.

Step Three
Adding Details

The artist painted Julie's face and features and added more washes of Raw Sienna, Scarlet Lake and a touch of Cerulean Blue as a shadow tone to her face and her torso, arms, legs, hands and feet.

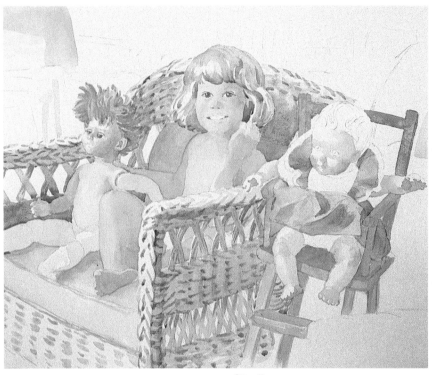

Step Two

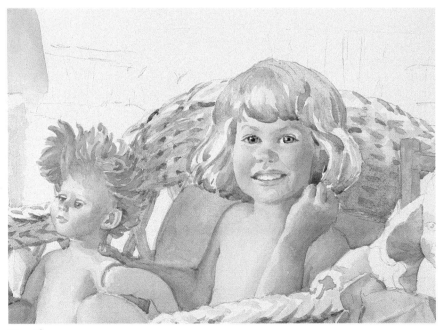

Step Three

Julie and Her Dolls

DEMONSTRATION

Step Four
Layering

All the white wicker furniture had to be kept in order—which chair was in front of which, and so on. The artist stayed with Cerulean Blue and Burnt Umber in varying intensities and in various layers.

The baby doll's head was painted with pale colors.

Step Five
Adding Background Details

The table behind the chairs was in the photograph, but after putting it in the painting, the artist didn't like it. She lifted it out with a cosmetic sponge, then re-painted that area.

The porch railing at the back wasn't really working, so various greens, made up of Olive Green, Raw Sienna and Cerulean Blue were added and allowed to mix on the paper rather than the palette.

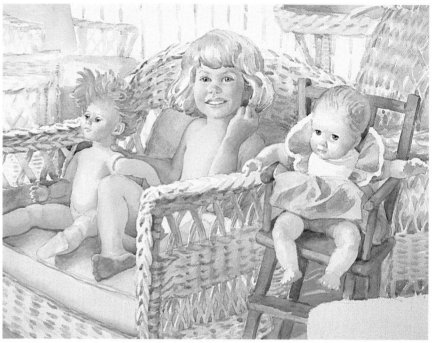

Step Four

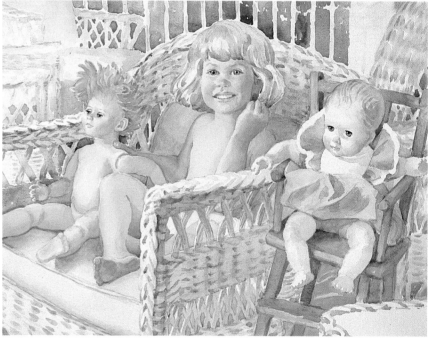

Step Five

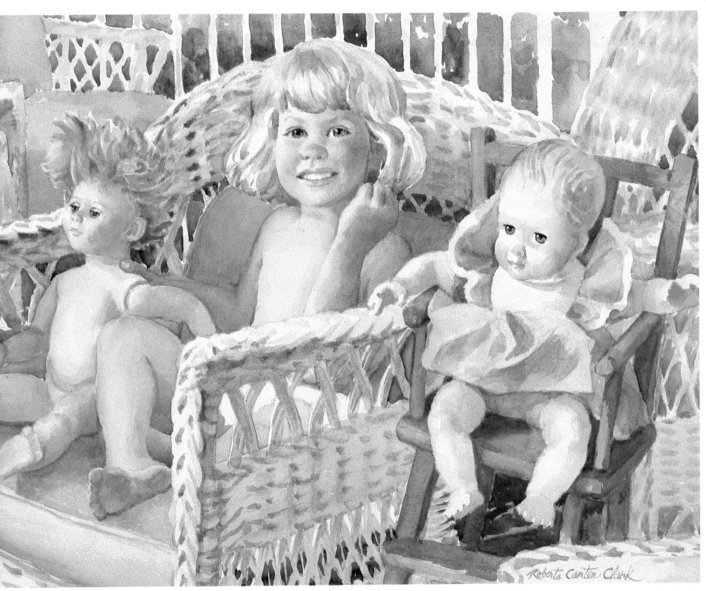

Julie, Age 4, and Her Dolls, 18½″ × 25″
Roberta Carter Clark

Step Six

Step Six
Finishing

After setting the painting aside for a few days, the artist intensified all the yellow cushions with more New Gamboge, adding Yellow Ochre and Cerulean Blue in the darker areas. Then two inches were cut off the bottom of the painting to focus more attention on the heads. After just a little more color was added to Julie's eyes, the painting was finished.

Painting Skin and Hair

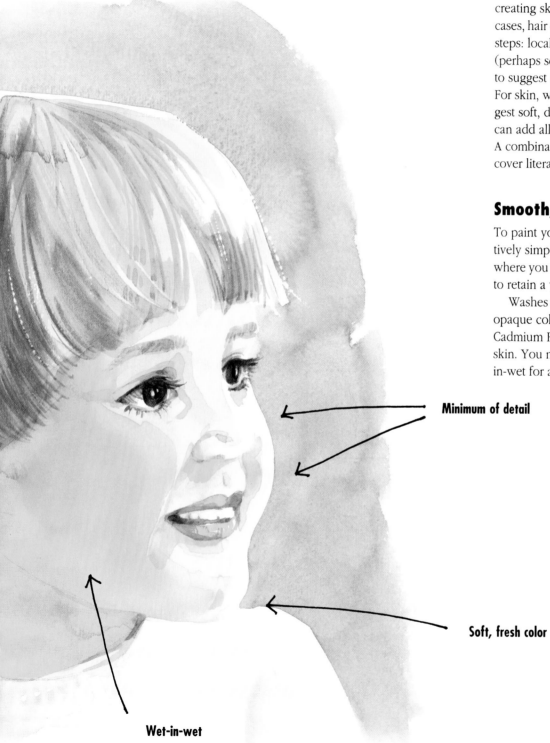

The watercolor technique you choose can go a long way toward creating skin and hair textures. In most cases, hair can be created in three simple steps: local color wash, shadow wash (perhaps scraped back into while damp to suggest strands of hair) and details. For skin, wet-in-wet can be used to suggest soft, delicate skin, while drybrush can add all the texture you'll ever need. A combination of these techniques can cover literally any skin texture.

Smooth, Young Skin

To paint young skin, keep washes relatively simple; try to put them down where you want them in one go in order to retain a youthful freshness.

Washes should be transparent; avoid opaque colors like Yellow Ochre and Cadmium Red when painting young skin. You may want to work partly wet-in-wet for a soft, youthful effect.

Minimum of detail

Soft, fresh color

Wet-in-wet

Basic People Painting Techniques in Watercolor

Weathered Skin

When painting a complexion with a little more of life written on it, you can have fun adding detail: crow's feet, facial planes, veins, expression lines, etc.

Color can be as bold as you like; here you can use opaque pigments, including some Burnt Sienna mixed into the shadow areas. Watch for expressive shadows, like those thrown by the eyeglasses.

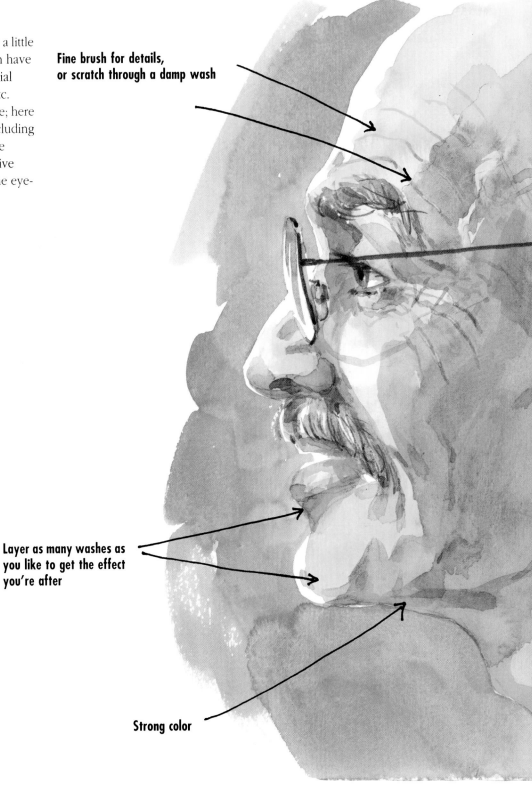

Fine brush for details, or scratch through a damp wash

Layer as many washes as you like to get the effect you're after

Strong color

Distant and Up Close

Consider how much detail is actually needed to capture your subject. In the *very* far distance, a single wash should be sufficient.

"Up close and personal," you can add as many layers as it takes to make you happy—but *do* allow previous washes to dry first to keep from getting muddy colors.

Shadow areas kept simple, too

Very simple washes—virtually no detail and only two washes used

A bit more facial detail

Transparent washes were used to model this close-up

Painting-around, blotting and lifting add highlights

From a somewhat lesser distance you may want to vary your underwash and add two or three shadow washes

Small details are added last

Here, three or four washes add character

Basic People Painting Techniques in Watercolor

Miscellaneous Hints

Choose your pigments according to the effect you're after and the color of your subject's skin.

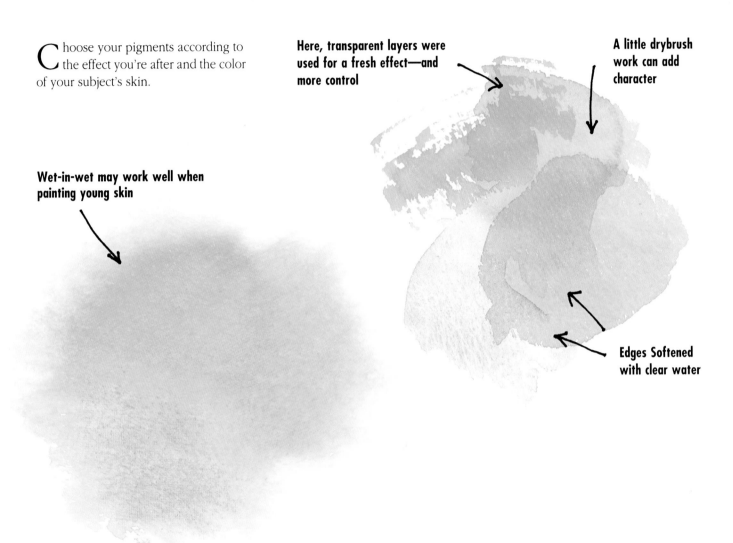

Wet-in-wet may work well when painting young skin

Here, transparent layers were used for a fresh effect—and more control

A little drybrush work can add character

Edges Softened with clear water

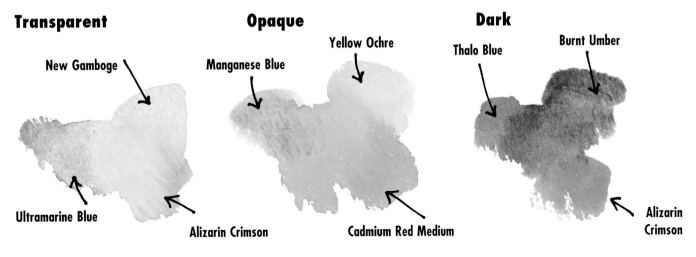

Transparent

New Gamboge

Ultramarine Blue

Alizarin Crimson

Opaque

Manganese Blue

Yellow Ochre

Cadmium Red Medium

Dark

Thalo Blue

Burnt Umber

Alizarin Crimson

Straight Hair

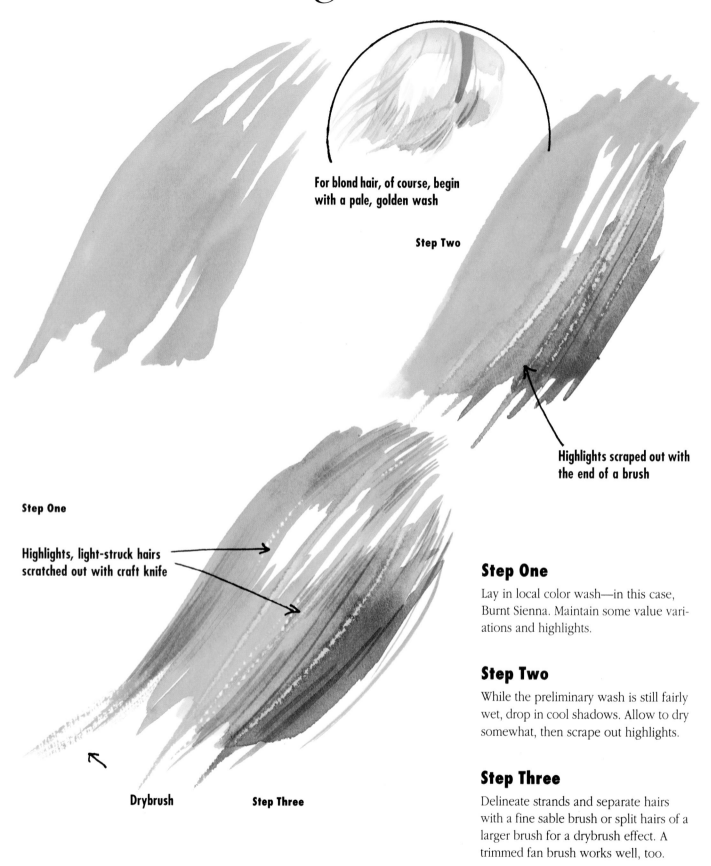

For blond hair, of course, begin with a pale, golden wash

Step Two

Highlights scraped out with the end of a brush

Step One

Highlights, light-struck hairs scratched out with craft knife

Drybrush **Step Three**

Step One

Lay in local color wash—in this case, Burnt Sienna. Maintain some value variations and highlights.

Step Two

While the preliminary wash is still fairly wet, drop in cool shadows. Allow to dry somewhat, then scrape out highlights.

Step Three

Delineate strands and separate hairs with a fine sable brush or split hairs of a larger brush for a drybrush effect. A trimmed fan brush works well, too.

Wavy Hair

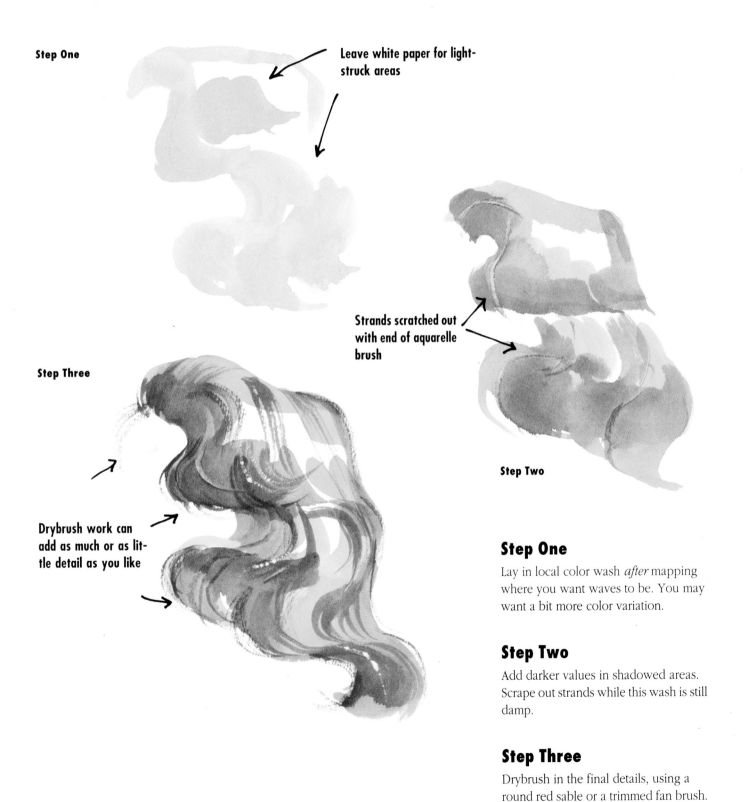

Step One

Leave white paper for light-struck areas

Strands scratched out with end of aquarelle brush

Step Two

Step Three

Drybrush work can add as much or as little detail as you like

Step One

Lay in local color wash *after* mapping where you want waves to be. You may want a bit more color variation.

Step Two

Add darker values in shadowed areas. Scrape out strands while this wash is still damp.

Step Three

Drybrush in the final details, using a round red sable or a trimmed fan brush. Scratch out strands with a craft knife.

Curly Hair

Whatever its length, curly hair follows basically the same form.

Step One

Lay in loose, somewhat lacy form with local color—for blond you can use Yellow Ochre or Raw Sienna. While this wash is still somewhat wet, come back in with a darker shadow wash. As the wsh loses its shine, you can incise highlights with a brush handle or fingernail.

Step Two

When the first washes are dry, add as much detail as you like using a small brush or a larger brush and drybrush-style. Here, a "barbered" fan brush was used to suggest ringlets.

Step One

Highlights scraped out with brush handle

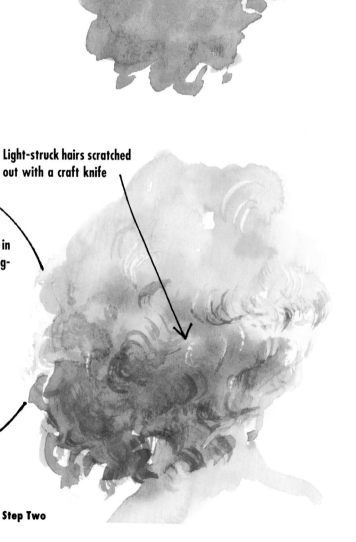

Light-struck hairs scratched out with a craft knife

Be sure to get plenty of color variation in curly black hair. *Don't* just use black pigment

Step Two

Basic People Painting Techniques in Watercolor

Facial Hair

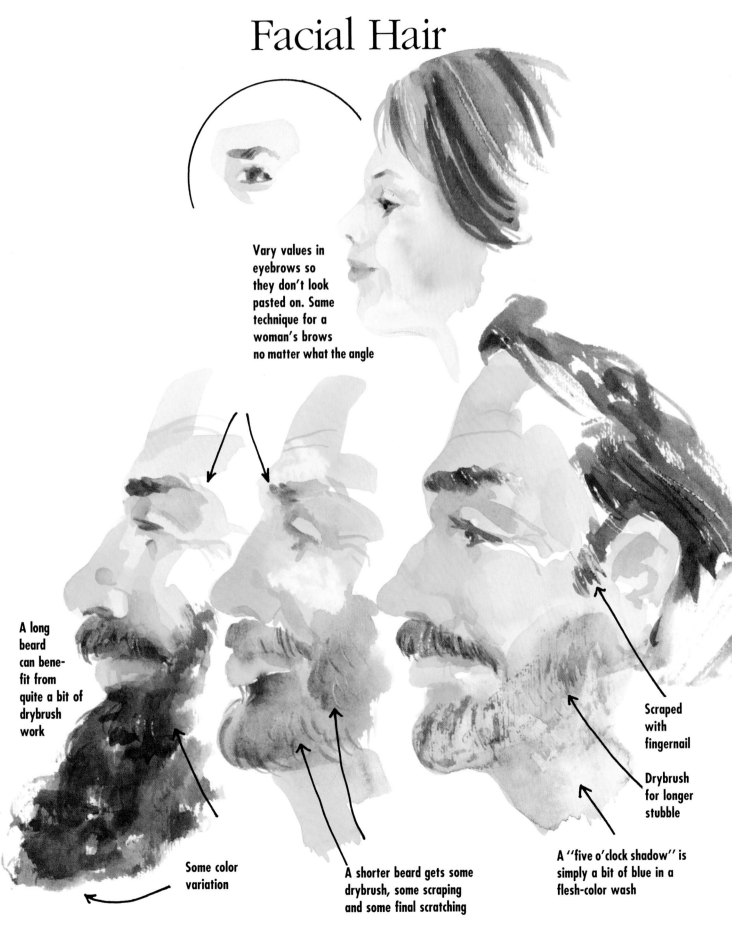

Vary values in eyebrows so they don't look pasted on. Same technique for a woman's brows no matter what the angle

A long beard can benefit from quite a bit of drybrush work

Some color variation

A shorter beard gets some drybrush, some scraping and some final scratching

Scraped with fingernail

Drybrush for longer stubble

A "five o'clock shadow" is simply a bit of blue in a flesh-color wash

Amanda Lee, age 4,
Roberta Carter Clark

Mountain Man, 20½" × 13½", Jan Kunz

Basic People Painting Techniques in Watercolor

INDEX

More Great Books for Beautiful Art!

1998 Artist's & Graphic Designer's Market: Where & How to Sell Your Illustration, Fine Art, Graphic Design & Cartoons—Your library isn't complete without this thoroughly updated marketing tool for artists and designers. The latest edition has 2,500 listings (and 700 are new!)—including such markets as greeting card companies, galleries, publishers and syndicates. You'll also find helpful advice on selling and showing your work from professionals, plus listings of art reps, artists' organizations and much more! #10514/$24.99/786 pages/paperback

Painting Sunlit Still Lifes in Watercolor—Capture the spills, splashes, leaps and dances of sunlight in watercolor! Thirty-three step-by-step demonstrations show you how to capture the sunlit textures of popular still life subjects—from sparkling crystal facets to rich wood grains. #30900/$28.99/144 pages/235 color illus.

Splash 1: America's Best Watercolors—Try new techniques as you discover the unique versatility of this luminous medium. You'll find a gallery of over 150 diverse works from 90 of the finest watercolor artists available—including valuable insights on how each composition was created! #31096/$22.99/144 pages/150+ color photos/paperback

Painting the American Heartland in Watercolor—Paint the spirit of the American countryside in watercolor using these proven, easy techniques. You'll work your way through simple scenes to more complex landscapes using 14 step-by-step projects designed to teach you how to paint all things country! #30912/$23.99/128 pages/172 color, 14 b&w illus./paperback

Painting Watercolor Portraits—Create portraits alive with emotion, personality and expression! Popular artist Al Stine shows you how to paint fresh and colorful portraits with all the right details—facial features, skin tones, highlights and more. #30848/$27.99/128 pages/210 color illus.

Step-By-Step Guide to Painting Realistic Watercolors—Now even the beginning artist can create beautiful paintings to be proud of! Full-color illustrations lead you step by step through 10 projects featuring popular subjects—roses, fruit, autumn leaves and more. #30901/$27.99/128 pages/230 color illus.

Painting Greeting Cards in Watercolor—Create delicate, transparent colors and exquisite detail with 35 quick, fun and easy watercolor projects. You'll use these step-by-step miniature works for greeting cards, framed art, postcards, gifts and more! #30871/$22.99/128 pages/349 color illus./paperback

The North Light Illustrated Book of Watercolor Techniques—Master the medium of watercolor with this fun-to-use, comprehensive guide to over 35 painting techniques—from basic washes to masking and stippling. #30875/$29.99/144 pages/500 color illus.

Capturing Light in Watercolor—Evoke the glorious "glow" of light in your watercolor subjects! You'll learn this secret as you follow step-by-step instruction demonstrated on a broad range of subjects—from sun-drenched florals, to light-filled interiors, to dramatic still lifes. #30839/$27.99/128 pages/182 color illus.

Creative Light and Color Techniques in Watercolor—Capture vibrant color and light in your works with easy-to-follow instruction and detailed demonstrations. Over 300 illustrations reveal inspiring techniques for flowers, still lifes, portraits and more. #30877/$21.99/128 pages/325 color illus./paperback

How to Draw Lifelike Portraits from Photographs—Using blended-pencil drawing techniques, you'll learn to create beautiful portraits that only look as though they were hard to draw. #30675/$24.99/144 pages/135 b&w illus.

How to Paint Living Portraits—Discover a wealth of ideas as 24 step-by-step demonstrations walk you through the basics of portraiture. Projects are shown in charcoal, oil and watercolor to help you master a variety of mediums. #30230/$28.99/176 pages/112 illus.

Drawing Expressive Portraits—Create lifelike portraits with the help of professional artist Paul Leveille. His easy-to-master techniques take the intimidation out of drawing portraits as you learn the basics of working with pencil and charcoal; how to draw and communicate facial expressions; techniques for working with live models and more! #30746/$24.99/128 pages/281 b&w illus.

Capturing the Magic of Children in Your Paintings—Create fresh, informal portraits that express the lively spirit and distinct personalities of children! In this book, designed to help artists in all the popular mediums, Jessica Zemsky shares the lessons she's learned in her many years of painting children—from finding natural poses to rendering varied skin and hair textures. #30766/$27.99/128 pages/130+ color illus.

How to Paint Skin Tones—Problem-solving instruction and practical color mixing charts will help you master one of painting's most basic and troublesome elements in all mediums. Charts of skin tone "recipes" will help you choose and mix colors accurately. Plus, projects and exercises will help you understand color, tone, structure, light and other factors that affect what you see and paint. #30700/$27.99/144 pages/400+ color illus.

Splash 4: The Splendor of Light—Discover a brilliant celebration of light that's sure to inspire! This innovative collection contains over 120 full-color reproductions of today's best watercolor paintings, along with the artists' thoughts behind these incredible works. #30809/$29.99/144 pages/124 color illus.

Watercolorist's Guide to Mixing Colors—Say goodbye to dull, muddled colors, wasted paint and ruined paintings! With this handy reference, you'll choose and mix the right colors with confidence and success every time. #30906/$27.99/128 pages/140 color illus.

Painting Expressive Portraits in Oil—Discover the keys to lively, expressive portraits. Step-by-step instructions show you how to get proportions, features, skin tones and hair color just right. #30918/$27.99/128 pages/239 color illus.